destroyed.

MOBY

DAMIANI

introduction

i've actually been taking pictures for as long as i've been making music.

when i was 9 years old (around the same time i started studying music) my uncle gave me my first camera, a nikon F. my uncle (joseph kugielsky) was a photographer for the new york times and national geographic, and i thought that he had the most glamorous job in the world (a photographer!). i remember when he gave me his old nikon F i felt like i'd been given a gift from the gods. this was a REAL camera, as up until that point i'd only taken bad snapshots on a 110 instamatic. the nikon F was completely manual, and it took amazing pictures (once i got a light meter and learned about exposure, before that my first 2 rolls came back completely black).

a few years after getting the nikon F my uncle gave me his old omega d-2 enlarger (i happily became the repository for all of the equipment that he had stopped using). once i learned how to work in a darkroom i became truly obsessed, shooting all day and developing and printing all night. i started saving up to buy photo books (as well as saving up to buy records and musical equipment), and when i was a teenager i became obsessed with edward steichen and andre kertesz and man ray and diane arbus (maybe it's strange to be obsessed with dead photographers when you're 16 years old?). i didn't know how to develop or print color film, so i only shot black and white and pretty much only paid attention to other photographers who shot black and white (which, luckily, was everyone).

as time passed i eventually went to suny purchase, where there was an amazing photo lab, which was great because it meant that i didn't have to mix my own chemicals anymore! the photo lab would open at 2pm, so i would get there promptly at 1:50 pm and stay until they closed. my life at that time was simple: make music, go to school (where i was a philosophy and photography double major, never quite graduating…), take pictures, develop and print, and play records so i could pay the rent, which was $50 a month, as i lived in an abandoned factory at the time. i experimented with larger formats, even experimenting with huge 3 feet X 3 feet liquid light canvasses with a friend of mine, but i always came back to 35mm as i loved the aspect ratio, how many shots i could get on a roll, and also how the grain looked when i shot high asa (i remember being very excited when they introduced 3200 asa with it's HUGE blobs of grain).

as time passed i got a digital camera and put my 35mm cameras and my enlarger into the basement (where they still reside). i admit, i miss film. i miss being in a darkroom for 6 hours at a time. but i love digital photography. i love the immediacy and the portability of shooting digital, and i love being able to shoot hundreds of images at a time (although i rarely do. i think that i still shoot like someone who has to process and print his own film. in other words: sparingly). on a technical note, i'm glad that i grew up shooting with a nikon F and processing and printing my own film, as i feel like it's helped me to approach photography differently than if i'd just grown up shooting digitally.

the pictures in this book were all taken on tour (and the songs on the album were all written on tour in strange hotel rooms).

i wanted to put out a book of tour photos, because touring is strange.

whereas most people think of touring as being unrelentingly glamorous, the truth is that touring is unrelentingly strange and disconcerting. i'm not complaining, but touring is, at its core, weird.

the strangeness of touring:
a-a constant nomadic, peripatetic daily existence.
b-the anonymous spaces (hotel rooms, backstage areas, airports)
c-the complete isolation (hotel rooms) juxtaposed with complete immersion in seas of people.
d-constantly existing in artificial spaces that have been created by other people.

again, i'm not complaining, but touring is weird and isolating.

i hope that somehow in these pictures i'm able to convey the mundanity of touring as juxtaposed with those moments of the disconcerting and/or the sublime. one minute on tour you're by yourself in a soul-less airport, the next minute you're flying over the most beautiful landscapes on the planet. one minute on tour you're by yourself in a soul-less backstage area, the next minute you're on stage in front of 75,000 people. touring is all contrasts and strangeness, and that's what i've tried to convey through these pictures. i also love the vacuum-like aesthetic of touring. 99% of the time while on tour you find yourself in completely life-less environments (hotel rooms, dressing rooms, airports), and then all of a sudden you're surrounded by thousands and thousands of people and strangers. touring tends to swing from the absurdly empty to the absurdly full. and from the absurdly lifeless to the absurdly fecund.

as i mentioned briefly, the music on the album (i still call them 'albums'…) was primarily written while on tour. and, for the most part, the music on the album was written in hotel rooms at 3 a.m when i was wide awake with insomnia and everyone else on the planet was, as far as i could tell, sleeping. the music on 'destroyed' and the photos in 'destroyed' work with each other, as they were both created at the same time in roughly the same environments and were inspired by the same daily touring experiences of the strange and the sublime.

these pictures weren't staged or planned, as they almost always involved me randomly looking out a window or looking across a room or looking across a sea of people and seeing something that seemed interesting at the time. in this quasi-random approach i was always inspired by andre kertesz, in that his pictures seemed accidental and formal at the same time, and his pictures possessed a sort of accidental beauty. one of my goals through my pictures is to take the normal and present it as odd and to take the odd and present it as, well, normal. or, at the very least, to take the quotidian and present it in a way wherein it's seen differently. and oh, to anyone who's come to one of my concerts: thanks. without you i probably would've just stayed home and taken pictures of the boring stuff in my kitchen. thank you for letting me go out into the world to see the strange and beautiful and mundane and sublime and disconcerting things i've been able to see.

–moby

introducción

En realidad llevo tanto tiempo haciendo fotos como haciendo música.

Cuando tenía 9 años (más o menos cuando empecé a estudiar música), mi tío me regaló mi primera cámara, una Nikon F. Mi tío (Joseph Kugielsky) era fotógrafo y trabajaba para el New York Times y la National Geographic, y yo estaba convencido de que tenía el trabajo más glamuroso del mundo (¡fotógrafo!). Recuerdo que cuando me regaló su vieja Nikon F me sentí como que me caía un regalo de los dioses. Esta era una cámara DE VERDAD, ya que hasta ese momento sólo había tomado instantáneas malas con una Instamatic 110. La Nikon F era totalmente manual y hacía fotos increíbles (una vez que conseguí un fotómetro y aprendí algo sobre la exposición porque antes de eso, los dos primeros rollos me habían salido totalmente negros).

Unos años después de recibir la Nikon F, mi tío me dio su vieja ampliadora Omega D-2 (yo, encantado, me convertí en el depositario de todo el equipo que él dejaba de utilizar). Una vez que aprendí a trabajar en un cuarto oscuro, me volví completamente obsesionado, hacienda fotos durante todo el día y revelando e imprimiendo durante toda la noche. Empecé a ahorrar para comprar libros de fotos (aparte de ahorrar para comprar discos y equipo musical) y, ya de adolescente me obsesioné con Edward Steichen, Andre Kertesz, Man Ray y Diane Arbus (¿puede que resulte extraño que un niño de dieciséis años se obsesione con fotógrafos muertos?). No sabía revelar ni imprimir en color, así que solo hacía fotos en blanco y negro y sólo prestaba atención a otros fotógrafos que hacían fotos en blanco y negro (que, por suerte, eran todos).

A medida que fue pasando el tiempo, llegó el día en que por fin fui a SUNY Purchase, donde había un laboratorio de fotos increíble, lo cual era genial porque ¡ya no tenía que mezclar los productos químicos yo mismo! El laboratorio fotográfico abría a las 2 de la tarde, así que llegaba puntual a las 13:50 y me quedaba hasta que cerraban. Mi vida en esa época era sencilla: hacer música, ir a la facultad (donde cursaba un doble grado en filosofía y fotografía, que nunca llegué a completar del todo…), hacer fotos, revelarlas e imprimirlas, pinchar discos para pagar el alquiler, que era $50 al mes, ya que por aquel entonces vivía en una fábrica abandonada. Experimenté con formatos mayores, llegando incluso a experimentar con enormes lienzos de emulsión fotográfica de 1 metro x 1 metro con un amigo mío, pero siempre volvía a los 35mm ya que me encantaba la relación de aspecto, cuántas fotos me cabían en un rollo, y también el aspecto del grano cuando hacía fotos con el ASA alto (recuerdo que me emocioné mucho cuando lanzaron el 3200 ASA con sus GIGANTESCOS trozos de grano).

A medida que fue pasando el tiempo, me compré una cámara digital y guardé mis cámaras de 35mm y mi ampliadora en el sótano (donde aún permanecen hoy). Reconozco que echo de menos las películas. Echo de menos pasar 6 horas seguidas en un cuarto oscuro. Pero me encanta la fotografía digital. Me encanta la inmediatez y la portabilidad de la foto digital. Me encanta poder tomar cientos de imágenes a la vez (aunque rara vez lo hago. Creo que sigo fotografiando como alguien que ha tenido que procesar e imprimirse sus propias películas. Es decir: con moderación). Un apunte técnico: me alegro de haberme criado fotografiando con una Nikon F y procesando e imprimiendo mis propias películas, ya que siento que me ha ayudado a abordar la fotografía de un modo distinto a si me hubiera criado haciendo fotos digitales.

Las fotos de este libro se hicieron todas estando de gira (y las canciones del álbum se escribieron todas estando de gira en extrañas habitaciones de hotel).

Quería sacar un libro de fotos de gira, porque las giras son raras.

Mientras que la mayoría pueden pensar que estar de gira es un no parar de glamur, la verdad es que estar de gira es un no parar de extrañeza y de desconcierto. No me quejo, pero las giras son, en esencia, muy raras.

La extrañeza de las giras:
a-una existencia diaria peripatética, permanentemente nómada.
b-los espacios anónimos (habitaciones de hotel, el backstage, aeropuertos)
c-el completo aislamiento (habitaciones de hotel) en yuxtaposición con la completa inmersión en multitudes.
d-la permanente existencia en espacios artificiales que han sido creados por otros.

Repito, no me quejo, pero estar de gira me hace sentir extrañeza y aislamiento.

Espero que de alguna forma estas imágenes logren transmitir la mundanidad de las giras como algo yuxtapuesto con esos momentos de desconcierto y/o de lo sublime. Cuando estás de gira, un momento estás solo en un aeropuerto desalmado y al siguiente estás sobrevolando los más bellos paisajes del planeta. Un instante estás solo en una zona desalmada del backstage y al siguiente estás en el escenario delante de 75.000 personas. Las giras son puro contraste y extrañeza y eso es lo que he buscado transmitir en estas imágenes. También me encanta la estética "de vacío" de las giras. El 99% del tiempo que estás te gira te encuentra en entornos completamente ausentes de vida (habitaciones de hotel, vestuarios, aeropuertos) y luego de repente, estás rodeado de miles y miles de personas y extraños. Las giras suelen ir de lo absurdamente vacío a lo absurdamente repleto. Y de lo absurdamente carente de vida a lo absurdamente fecundo.

Como he mencionado brevemente, la música del álbum (yo los sigo llamando 'álbumes') fue escrita principalmente de gira. Y, en su mayor parte, la música del álbum fue escrita en habitaciones de hotel a las 3 de la mañana cuando estaba totalmente despierto por el insomnio y todas las demás personas en el planeta, o eso me parecía a mí, dormían. La música de 'destroyed' y las fotos de 'destroyed' funcionan juntas, ya que se crearon ambas a la vez en más o menos los mismos entornos y se inspiraron en las mismas experiencias diarias de lo raro y lo sublime estando de gira.

Estas imágenes no fueron escenificadas ni planificadas, ya que casi siempre surgían de un acto aleatorio de mirar por una ventana o al otro lado de una habitación o frente a un mar de personas y detectar algo que en ese momento me parecía interesante. En este enfoque cuasi-aleatorio siempre me inspiró Andre Kertesz, en el sentido en que sus imágenes parecían accidentales y formales al mismo tiempo, y sus imágenes poseían una suerte de belleza accidental. Uno de mis objetivos con mis fotografías es coger lo normal y presentarlo como raro o coger lo raro y presentarlo como, bueno…, normal. O, al menos, coger lo cotidiano y presentarlo de tal modo que se ve de forma diferente. Ah! Y a todos los que hayan ido alguna vez a uno de mis conciertos: gracias. Sin vosotros es probable que simplemente me hubiera quedado en casa y hecho fotos de cosas aburridas en mi cocina. Gracias por dejarme salir por el mundo y ver las cosas raras y bellas y mundanas y sublimes y desconcertantes que he podido ver.

–moby

introduction

J'ai commencé la photo en même temps que la musique.

Quand j'avais 9 ans (j'avais à peu près le même âge lorsque j'ai commencé à étudier la musique), mon oncle m'a donné mon premier appareil photo, un Nikon F. Mon oncle (Joseph Kugielsky) était photographe pour le New York Times et le National Geographic et je pensais qu'il faisait le plus beau métier du monde (photographe!). Je me rappelle lorsqu'il m'a donné son vieux Nikon F. C'était comme si je venais de recevoir un don des dieux. C'était un VRAI appareil photo alors que jusqu'alors je ne faisais que de mauvais instantanés avec un 110 instamatic. Le Nikon F était totalement manuel et il faisait de super photos (un jour, j'ai eu un posemètre et j'ai appris ce qu'était l'exposition avant que mon deuxième rouleau ne revienne complètement noir).

Quelques années après le Nikon F, mon oncle m'a donné son vieil agrandisseur Omega d-2 (j'ai eu la chance de devenir son dépôt pour tout le matériel qu'il n'utilisait plus). J'ai appris à travailler dans une chambre noire et je suis devenu vraiment obsédé: je faisais des photos toutes la journée et je développais et tirais toute la nuit. J'ai commencé à économiser pour acheter des livres de photos (de même que j'économisais pour acheter du matériel d'enregistrement et de musique) et quand j'étais adolescent, j'étais obsédé par Edward Steichen, Andre Kertesz, Man Ray et Diane Arbus (peut-être est-il étrange d'être obsédé à 16 ans par des photographes morts ?). Je ne savais pas développer ou tirer les pellicules couleur, alors je ne faisais que du noir et blanc et je m'intéressais toujours plus aux autres photographes qui faisaient du noir et blanc (ce qui était le cas de tous, heureusement).

Le temps est passé et je suis enfin entré à Suny Purchase où il y avait un labo photo extraordinaire, ce qui était génial parce que je n'avais plus besoin de faire mes propres mélanges chimiques ! Le labo photo ouvrait à 2 heures de l'après-midi donc j'arrivais à 13 h 50 et j'y restais jusqu'à ce qu'il ferme. Ma vie était simple à l'époque : faire de la musique, aller à l'école (où j'ai étudié philosophie et photographie, sans jamais me diplômer), faire des photos, les développer et les tirer, faire le DJ, ce qui me permettait de payer mon loyer, qui était de 50$ par mois car je vivais alors dans une usine abandonnée. J'ai essayé les formats larges, j'ai même essayé du liquid light sur des toiles immenses de 3 pieds sur 3 avec l'un de mes amis, mais je suis toujours revenu vers le 35mm car j'aimais son aspect, le nombre de prises que je pouvais faire avec une pellicule, et le grain lorsque je prenais des photos avec un asa élevé (je me rappelle avoir été très excité lorsqu'ils ont introduit le 3200 asa avec ses énormes grains).

Ensuite j'ai eu un appareil photo numérique ; j'ai mis au placard mes appareils 35mm et mon agrandisseur (ils y sont encore). Je reconnais que les pellicules me manquent. Le fait de rester 6 heures dans une chambre noire me manque. Mais j'aime la photo numérique. J'aime l'immédiateté et la portabilité de la photo numérique, et j'adore pouvoir faire des centaines d'images à la fois (même si je le fais rarement. Je pense que je prends encore des photos comme quelqu'un qui doit développer et tirer sa pellicule, c'est-à-dire en petite quantité). D'un point de vue technique, je suis heureux d'avoir grandi avec un Nikon F et d'avoir développé et tiré mes pellicules, car je sens que cela m'a aidé à avoir une approche différente de la photographie que si j'avais grandi avec le numérique.

Les photos de ce livre ont toutes été prises pendant les tournées (et les chansons de l'album ont été écrites dans d'étranges chambres d'hôtels).

Je voulais faire une livre de photos de tournée car c'est étrange une tournée.

Alors que beaucoup de gens pensent que ce doit être génial, c'est en réalité étrange et déconcertant. Je ne me plains pas mais faire une tournée, au fond, c'est bizarre.

L'étrangeté de la tournée :
a- une existence quotidienne constamment nomade, péripatétique.
b- les espaces anonymes (chambres d'hôtel, coulisses, aéroports)
c- l'isolement complet (chambres d'hôtels) puis une immersion complète dans une mer de personnes.
d- exister constamment dans des espaces artificiels qui ont été créés par d'autres.

Je répète, je ne me plains pas, mais une tournée, c'est bizarre et isolant.

J'espère que dans certaines de ces photos j'arrive à transmettre la mondanité de la tournée à côté de ces moments de déconcertement et/ou de sublime. En tournée, vous êtes seuls dans un aéroport sans âme, puis la minute d'après vous volez au-dessus des paysages les plus beaux de la planète. Vous êtes seuls dans des coulisses sans âme, puis la minute d'après vous êtes sur la scène face à 75 000 personnes. Une tournée est faite de contrastes et d'étrangeté et c'est ce que j'ai essayé de transmettre à travers ces photos. J'aime aussi l'esthétique de la tournée, proche du vide. Vous passez 99% de votre temps dans des environnements sans vie (chambres d'hôtel, loges, aéroports) puis tout à coup vous êtes entourés par des milliers et des milliers de personnes et d'étrangers. En tournée, on tend à balancer entre l'absurdement vide et l'absurdement plein. Et entre l'absurdement mort et l'absurdement fécond.

Comme je l'ai brièvement mentionné, la musique de mon album (je continue à les appeler 'albums'...) a d'abord été écrite lorsque j'étais en tournée. Et la plus grande partie de la musique sur l'album a été écrite dans des chambres d'hôtel à 3 heures du matin lorsqu'une insomnie me tenait éveillé et que tout le monde, aussi loin que je puisse le voir, était en train de dormir. La musique sur du 'détruit' et les photos dans le 'détruit' travaillent ensemble car elles ont été créées au même moment, en général au même endroit, et elles ont été inspirées par les mêmes expériences quotidiennes d'étrangeté et de sublime pendant la tournée.

Ces images n'ont été ni mises en scène ni planifiées car elles m'ont presque toujours impliqué lorsque je regardais par la fenêtre, à travers la pièce ou une mer de personnes et que je voyais quelque chose qui semblait alors intéressant. Dans cette approche presque aléatoire, j'ai été inspiré par Andre Ketesz, car ses images semblaient à la fois accidentelles et formelles et elles possédaient une sorte de beauté accidentelle. L'un de mes objectifs à travers ces photos est de faire passer le normal pour bizarre et le bizarre pour normal. Ou au fond de prendre le quotidien pour le présenter de manière à ce qu'il semble différent. Un grand merci à tous ceux qui sont venus à mes concerts. Sans vous, je serais sûrement resté à la maison à prendre des photos ennuyeuses de ma cuisine. Merci de m'avoir laissé sortir dans le monde pour voir l'étrange et le beau, et de m'avoir montré les choses étranges, belles, mondaines, sublimes et déconcertantes que j'y ai vu.

–moby

introduzione

La mia passione per la fotografia è nata insieme a quella per la musica.

Quando avevo nove anni (più o meno nel periodo in cui ho iniziato a studiare musica), mio zio (Joseph Kugielsky) mi regalò la mia prima macchina fotografica, una Nikon F. Lui faceva il fotografo per il «New York Times» e il «National Geographic», e a me il suo mestiere sembrava il più appassionante del mondo. Quando mi passò la sua vecchia Nikon, ricordo che mi sembrò di ricevere un regalo dagli dei. Quella sì che era una macchina fotografica; fino a quel momento mi ero accontentato di scattare certe istantanee orribili con una 110 Instamatic. La Nikon F era completamente manuale, e le fotografie venivano benissimo (almeno dopo che mi procurai un esposimetro e imparai a regolare l'esposizione, perché nei primi due rullini non si vedeva niente).

Qualche anno dopo la Nikon F, mio zio mi regalò il suo vecchio ingranditore Omega D2 (avevo la fortuna di entrare in possesso di tutta l'attrezzatura che smetteva di usare). Imparai il funzionamento della camera oscura, e per me diventò una vera ossessione: passavo le giornate a scattare, e le notti a sviluppare e stampare. Iniziai a mettere da parte i soldi per comprarmi libri fotografici (oltre ai dischi e all'attrezzatura musicale), e da adolescente diventai un fanatico di Edward Steichen, Andre Kertesz, Man Ray e Diane Arbus (non so se sia tanto normale, a sedici anni, essere fissati con tutti quei fotografi morti). Non sapendo sviluppare la pellicola a colori, scattavo sempre in bianco e nero, quindi mi interessavano solo i fotografi che scattavano in bianco e nero (praticamente tutti, per mia fortuna).

Dopo qualche anno iniziai a frequentare il SUNY Purchase, dove avevamo a disposizione un fantastico laboratorio fotografico, così potevo smettere di comprarmi i prodotti da solo! Il laboratorio apriva alle due del pomeriggio, io mi presentavo alle due meno dieci e restavo fino alla chiusura. All'epoca la mia vita era semplice: suonavo, andavo al college (frequentavo i corsi di filosofia e di fotografia, anche se non mi laureavo mai…), scattavo, sviluppavo e stampavo fotografie, e mettevo dischi per pagarmi l'affitto, che era di cinquanta dollari al mese, dato che vivevo in una fabbrica abbandonata. Feci qualche esperimento con formati più grandi, e per un periodo, insieme a un amico, realizzai enormi stampe con emulsione liquida su tele di un metro per un metro, ma finivo sempre per tornare al 35mm, perché mi piacevano le proporzioni del fotogramma, e mi divertiva fare prove per scoprire quanti scatti potevo fare con un rullo e quanto grossa risultava la grana se utilizzavo asa alti (ricordo il mio entusiasmo quando immisero sul mercato le pellicole a 3200 asa, che davano immagini sgranate al massimo).

Dopo qualche tempo, mi comprai una macchina digitale e gli apparecchi 35mm finirono in cantina insieme all'ingranditore (tuttora si trovano lì). Devo ammetterlo, la pellicola mi manca. Mi manca il fatto di passare sei ore di fila in una camera oscura. D'altra parte, però, adoro la fotografia digitale: adoro l'immediatezza e la comodità di girare con una macchina così piccola, e la possibilità di scattare centinaia di immagini alla volta (anche se in pratica non lo faccio quasi mai. Penso di scattare con una certa parsimonia, come se dovessi ancora svilupparmi la pellicola da solo). Dal punto di vista tecnico, sono contento di aver imparato la fotografia scattando con una Nikon F e stampandomi le foto, perché penso che questo mi abbia aiutato ad avere un approccio diverso che non se fossi partito subito dal digitale.

Le fotografie di questo libro sono state tutte realizzate in tour (come le canzoni del disco, scritte per la maggior parte in alienanti camere d'albergo).

Volevo fare un libro fotografico sul tour, perché si tratta di un'esperienza davvero molto strana.

Un sacco di gente pensa che andare in giro a fare concerti sia la cosa più affascinante del mondo, ma in realtà è strano e spiazzante. Non lo dico per lamentarmi, ma si tratta di un'esperienza disorientante, per tutta una serie di fattori:

a- un'esistenza costantemente nomade e randagia
b- gli spazi anonimi (camere d'albergo, aree backstage, aeroporti)
c- l'isolamento totale (camere d'albergo) alternate all'immersione in un mare di persone
d- il fatto di occupare sempre spazi artificiali creati da altri.

Ripeto, non ho la minima intenzione di lamentarmi, ma andare in tour è un'esperienza estraniante, che ti espone a una certa solitudine.

Spero di essere riuscito, in queste fotografie, a trasmettere l'atmosfera della vita in tour, la banalità che si alterna a momenti disorientanti e/o sublimi. A volte ti capita di essere solo in un aeroporto senz'anima, e un attimo dopo stai volando sui paesaggi più belli del pianeta. Oppure sei tutto solo in un anonimo backstage, e un attimo dopo sei catapultato in scena davanti a 75.000 persone. I tour sono fatti di contrasti e alienazione, e nelle foto ho cercato di trasmettere tutte queste sfumature. Mi piace anche l'estetica anonima di questo modo di viaggiare. Passi il novantanove per cento del tempo in ambienti privi di vita (stanze di hotel, camerini, aeroporti), e poi a intervalli ti trovi circondato da migliaia e migliaia di estranei. Si tende a oscillare dal troppo pieno al vuoto totale. E dalla massima sterilità alla massima creatività.

Come ho già accennato, la musica dell'album (io mi ostino a chiamarli "album"…) è stata scritta quasi per intero durante il tour. Spesso alle tre di notte, quando l'insonnia mi teneva sveglio e mi pareva che chiunque altro sul pianeta stesse dormendo. La musica di 'destroyed' e le fotografie di 'destroyed' interagiscono, perché sono state create nello stesso periodo, più o meno negli stessi contesti, e sono state ispirate dalle stesse esperienze, disorientanti e sublimi, di una giornata in tour.

Queste fotografie non hanno niente di premeditato o costruito: in genere è successo che stavo vagando con lo sguardo in una stanza, una folla, o fuori dalla finestra, e ho visto una cosa che sul momento mi è sembrata interessante. Questo approccio quasi aleatorio mi è stato ispirato da Andre Kertesz: i suoi scatti riescono ad apparire al tempo stesso accidentali e formali, come se rappresentassero la bellezza del caso. Uno dei miei obbiettivi, quando fotografo, è catturare l'ordinario e presentarlo come insolito, o viceversa catturare l'insolito e farlo sembrare ordinario. O semplicemente ritrarre il quotidiano e mostrarlo da un altro punto di vista. A proposito, ci terrei a ringraziare tutti quelli che sono venuti almeno una volta ai miei concerti. È molto probabile che senza di loro sarei rimasto chiuso in casa a immortalare qualche noioso oggetto nella mia cucina. Grazie a tutti per avermi permesso di uscire nel mondo, e di vedere le cose strane, splendide, banali, sublimi e sconcertanti che ho visto.

–moby

Einführung

Seit ich Musik mache, mache ich auch Fotos.

Als ich 9 Jahre alt war (ungefähr zur selben Zeit fing ich an, Musikunterricht zu nehmen) schenkte mir mein Onkel eine Nikon F, meine erste Kamera. Mein Onkel (Joseph Kugielsky) fotografierte für die New York Times und National Geographic und ich fand, er hätte den glamourösesten Job der Welt (ein Fotograf!). Als er mir seine alte Nikon F schenkte, war es, als hätte ich ein Geschenk der Götter bekommen. Es war eine echte Kamera, bisher hatte ich nur schlechte Schnappschüsse mit einer 110 Instamatic machen können. Die Nikon F war rein manuell und machte erstaunliche Bilder (nachdem ich auch ein Lichtmessgerät bekommen und etwas über Belichtung gelernt hatte - davor waren erst mal zwei völlig schwarze Filme zurückgekommen).

Ein paar Jahre später gab mir mein Onkel seinen alten Omega D-2 Vergrößerer (ich war ein dankbarer Abnehmer für all sein stillgelegtes Equipment geworden). Bald kannte ich mich in der Dunkelkammer aus, knipste den ganzen Tag und entwickelte die ganze Nacht wie ein Besessener. Ich sparte für Fotobücher (sowie für Platten und Musikinstrumente) und als Teenager war ich von Edward Steichen, Andre Kertesz, Man Ray und Diane Arbus schwer beeindruckt (vielleicht ein bisschen seltsam, als sechzehnjähriger von toten Fotografen besessen zu sein?). Da ich keine Farbfilme entwickeln oder abziehen konnte, schoss ich nur Schwarz-weiß und schenkte anderen Fotografen Beachtung, wenn sie Schwarz-weiß fotografierten (was Gott sei Dank alle taten).

Im Lauf der Zeit landete ich bei Suny Purchase, wo es ein irres Fotolabor gab. Das war fantastisch, weil ich keine Chemikalien mehr anmischen musste. Das Labor machte um 14 Uhr auf - ich stand um 13.50 Uhr vor der Tür und blieb bis Ladenschluss. Damals war mein Leben einfach: Musik machen, zur Schule gehen (ich belegte Philosophie und Fotografie und stand immer kurz vor dem Abschluss), fotografieren, entwickeln, abziehen, und Platten auflegen um die Miete bezahlen zu können - 50 Dollars im Monat für einen Raum in einer verlassenen Fabrik. Ich versuchte mich an größeren Formaten, experimentierte sogar mit riesigen 3x3 Fuß großen Liquid Light Leinwänden, kam aber immer wieder auf die 35 mm zurück: ich liebte es zu sehen, wie viele Schüsse man auf einen Film kriegen kann, wie grobkörnig die Bilder kommen, wenn man mit hohen ASA-Werten arbeitet (ich hatte es kaum erwarten können, den neuen 3200 ASA Film mit seinem Riesen-Korn auszuprobieren).

Irgendwann kaufte ich dann eine Digitalkamera und verstaute meine 35 mm-Kameras und den Vergrößerer in den Keller (wo sie immer noch verweilen). Ich gestehe, ich vermisse den Film. Ich vermisse es, 6 Stunden und länger in einer Dunkelkammer zu sein. Aber ich mag die Digitalfotografie. Ich mag das Jetzt-und-hier und ich liebe es, hundert Bilder auf einmal schießen zu können (auch wenn ich das fast nie mache; ich denke, ich fotografiere immer noch wie jemand, der seinen eigenen Film entwickeln und abziehen muss - sehr sparsam). Ich bin froh, mit einer Nikon F, mit Film und Entwickler aufgewachsen zu sein, denn dadurch habe ich einen bewussteren Zugang zur Fotografie gefunden, als dies im Digitalzeitalter möglich wäre.

Die Bilder in diesem Buch wurden alle auf Tournee gemacht (so wie die Lieder des Albums alle auf Tournee, in seltsamen Hotelzimmern geschrieben sind). Ich wollte ein Buch mit Tourneefotos machen, denn auf Tournee sein ist seltsam. Viele Leute meinen, auf Tournee sein wäre unwahrscheinlich glamourös, in Wirklichkeit ist es unwahrscheinlich verwirrend und beunruhigend. Ich will mich nicht beklagen, aber so ist das mit dem Tournee-leben.

Es ist gekennzeichnet durch:
a-ständiges Umherwandeln, eine dauerhafte Nomadenexistenz.
b-anonyme Orte (Hotelzimmer, Backstage, Flughäfen).
c-völlige Isolation (Hotelzimmer), in scharfem Kontrast zum Bad in der Menschenmenge.
d-Aufenthalt in künstlichen, von Fremden geschaffenen Räumen.
Nochmal, ich will mich nicht beklagen, aber die Tournee macht einsam.

Ich hoffe, dass diese Bilder es irgendwie schaffen, sowohl die aufregenden, sublimen, als auch die verstörenden Tournee-momente zu erzählen. Gerade noch stehst du verloren in einer seelenlosen Flughafenhalle, im nächsten Moment fliegst du schon über die schönsten Landschaften der Welt. Gerade noch sitzt du allein im anonymen Backstage-bereich, plötzlich findest du dich auf der Bühne vor 75000 Menschen wieder. Starke Kontraste und Entfremdung - das heißt für mich auf Tournee sein und das ist es, was ich in Bildern zu erzählen versuche. Ich liebe die vakuum-artige Ästhetik der Tournee. Die meiste Zeit verbringst du an völlig leblosen Orten, dann bist du wieder von tausenden fremden Menschen umgeben. Auf Tournee bleibt nichts ohne sein Gegenteil: absurd leer und absurd voll, absurd leblos und absurd fruchtbar.

Die Musik auf diesem Album (ich sage immer noch 'Album'...) habe ich, wie gesagt, fast ausschließlich auf Tour geschrieben. Die meisten Lieder entstanden gegen 3 Uhr morgens in irgendeinem Hotelzimmer, in dem ich schlaflos wachte, während der gesamte Rest der Welt in tiefen Schlaf versunken schien. Die Musik und die Bilder von 'Destroyed' arbeiten zusammen, weil sie zur selben Zeit, in derselben Umgebung entstanden sind und weil sie von denselben verstörenden Erfahrungen des Touralltags inspiriert sind.

Die Bilder sind nicht konstruiert oder geplant, ich habe einfach nur festgehalten, was mein Auge zu einem bestimmten Zeitpunkt einfing - sei es ein zufälliger Blick aus dem Fenster, quer durch das Zimmer, oder über das Menschenmeer hinweg. Dieses eher zufällige Herangehen erinnert mich immer an die Arbeiten von Andre Kertesz, deren zufällige Schönheit auch formal vollkommen ist. Ein Ziel meiner Arbeit ist das Normale merkwürdig und das Merkwürdige, naja, normal erscheinen zu lassen. Oder das Alltägliche wenigstens ein bisschen anders zu betrachten. Ach so, und jedem, der eines meiner Konzerte besucht hat, sage ich: danke. Ohne Euch wäre ich wahrscheinlich einfach zu Hause geblieben und hätte langweilige Bilder von meiner Küche gemacht. Danke, dass Ihr mich raus in die weite Welt geschickt habt, wo ich die seltsamen und schönen und ernüchternden und sublimen und verwirrenden Dinge sehen konnte, die ich gesehen habe.

—moby

destroyed.

nyc

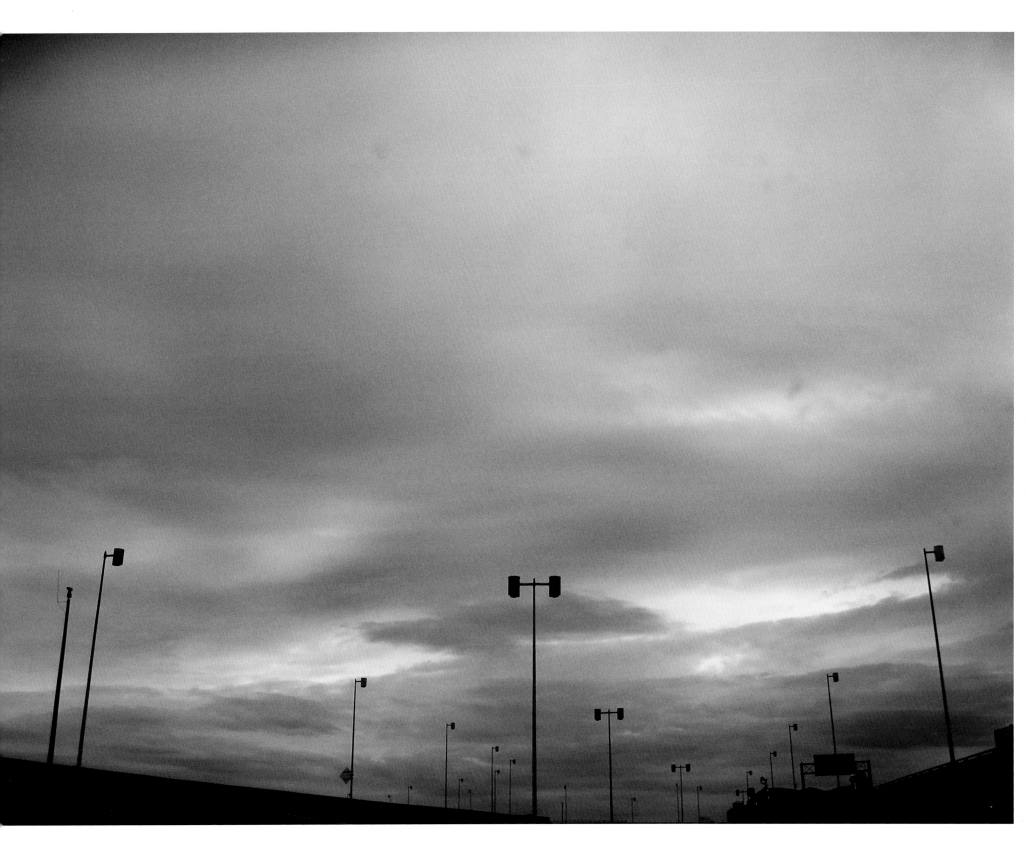

manchester

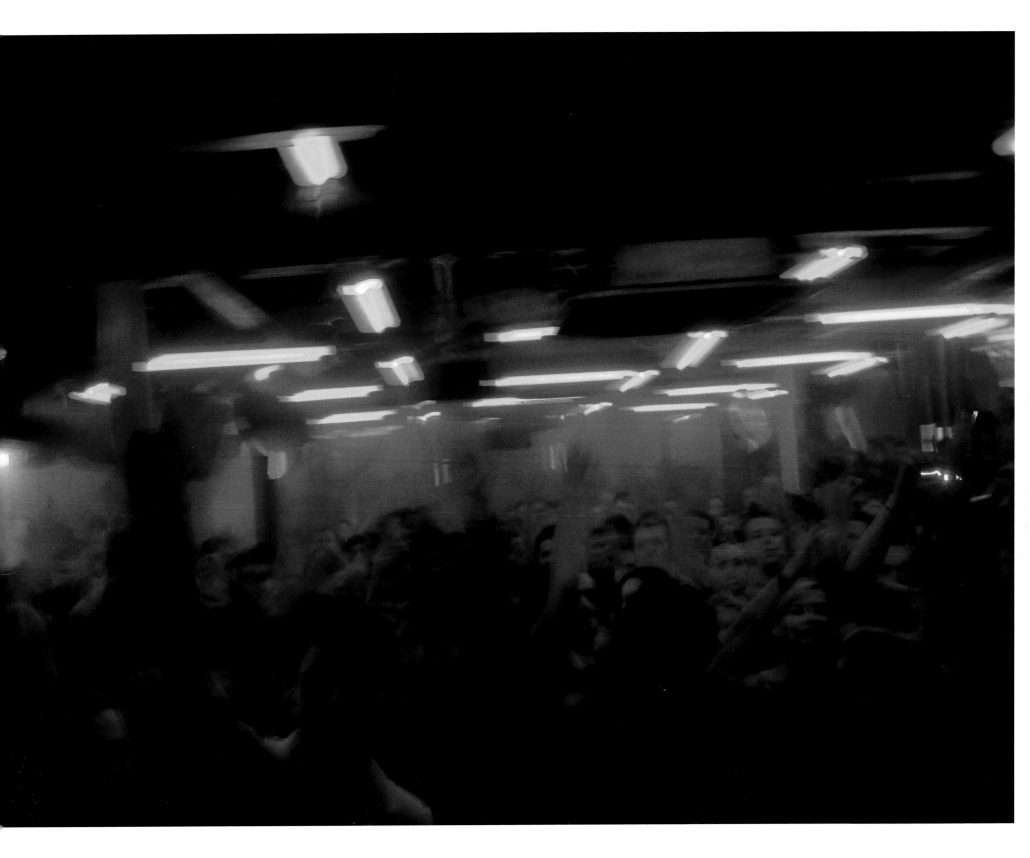

chicago

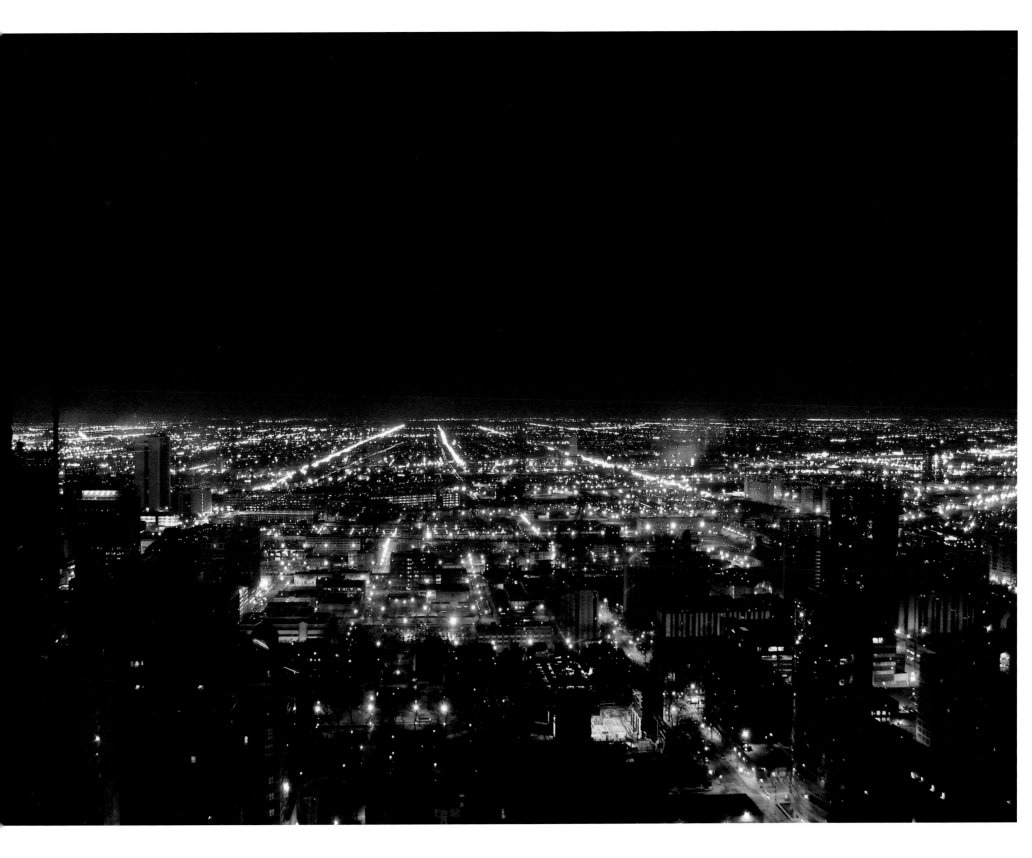

brussels

berlin

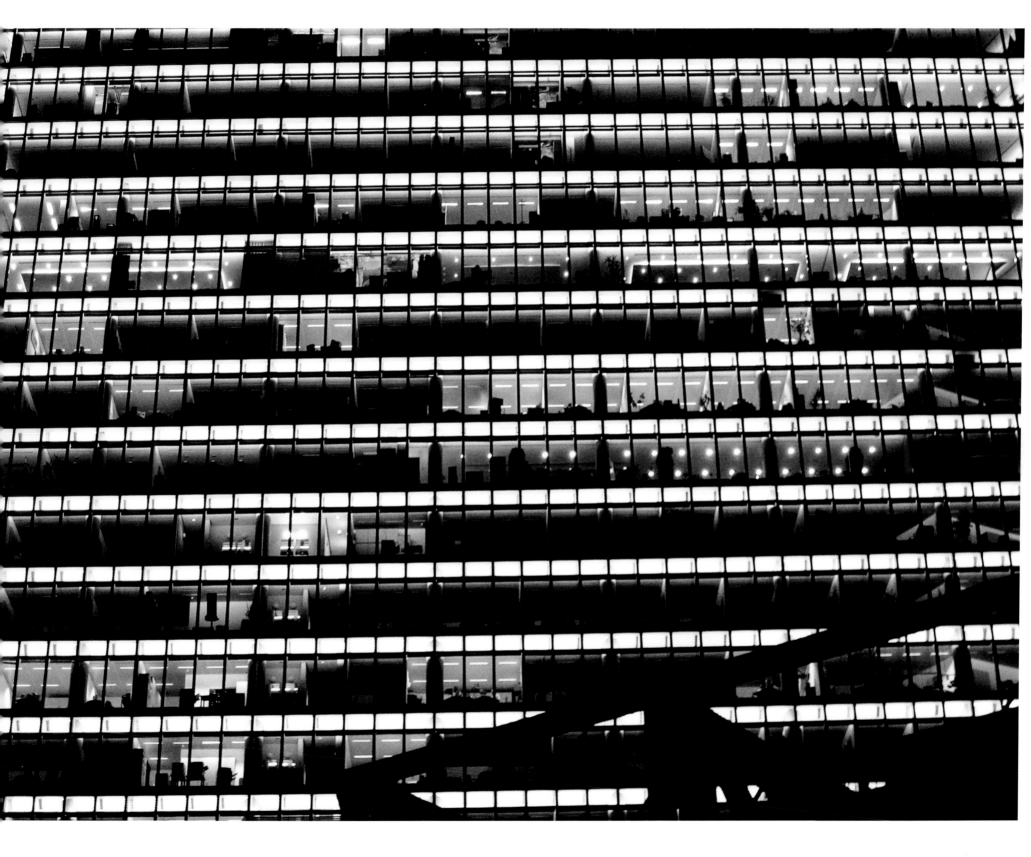

paris

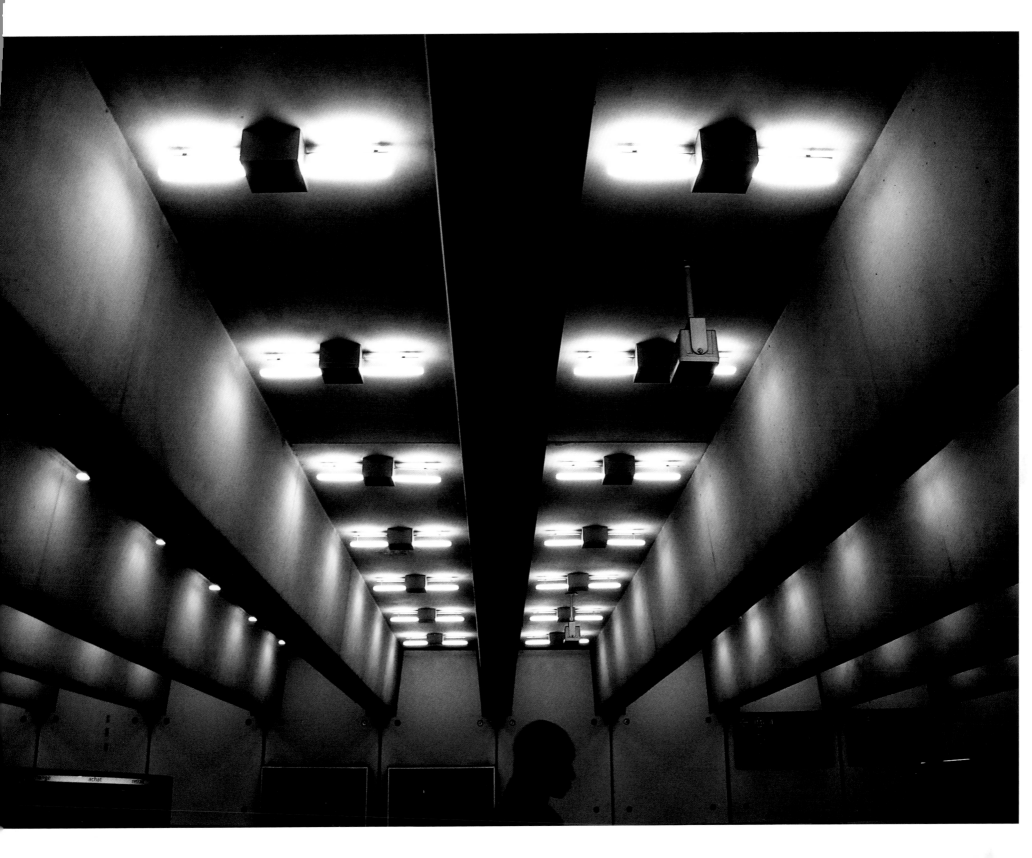

perth

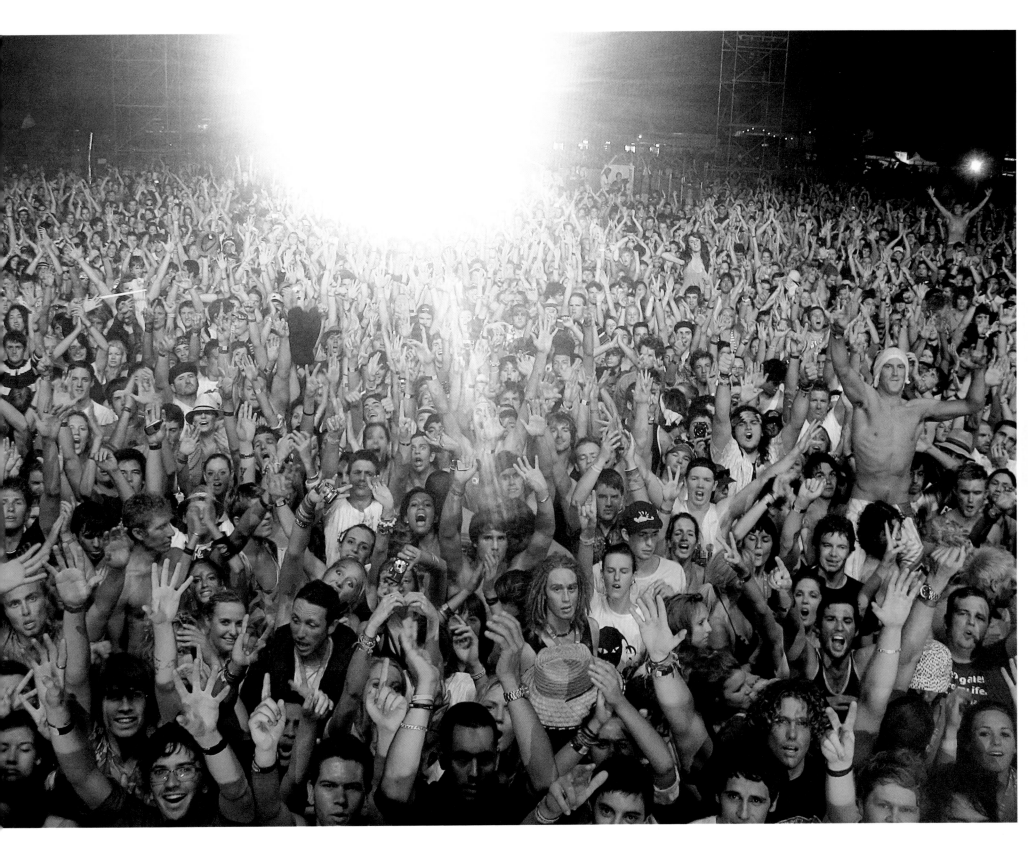

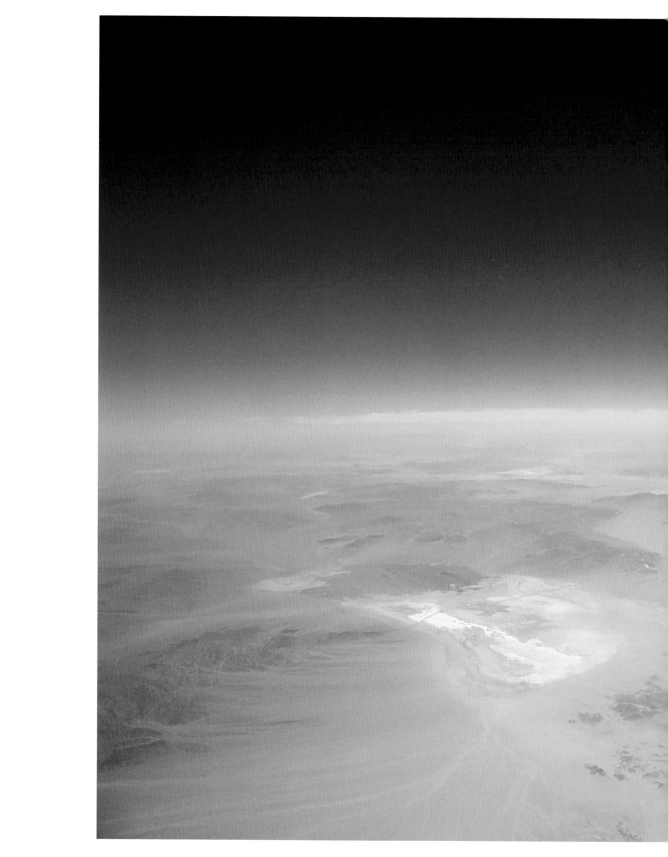

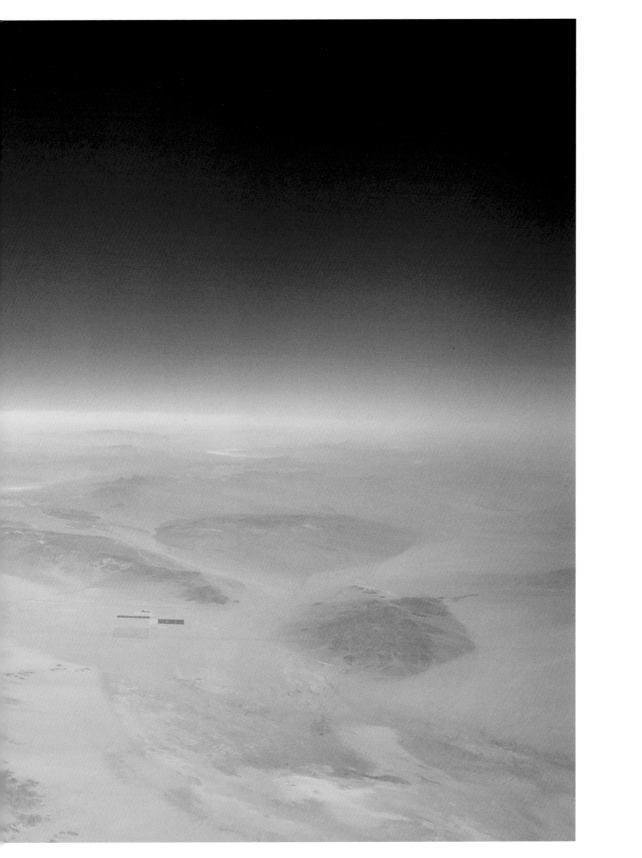

newark

« desert, california

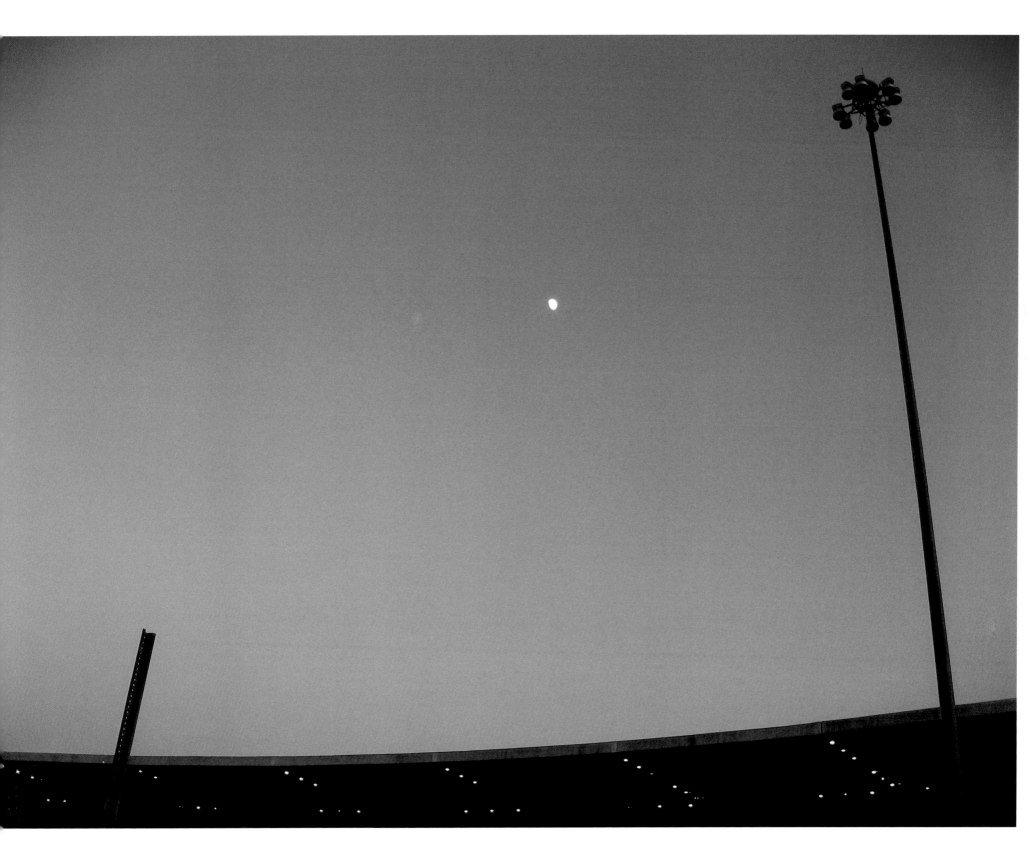

geneva

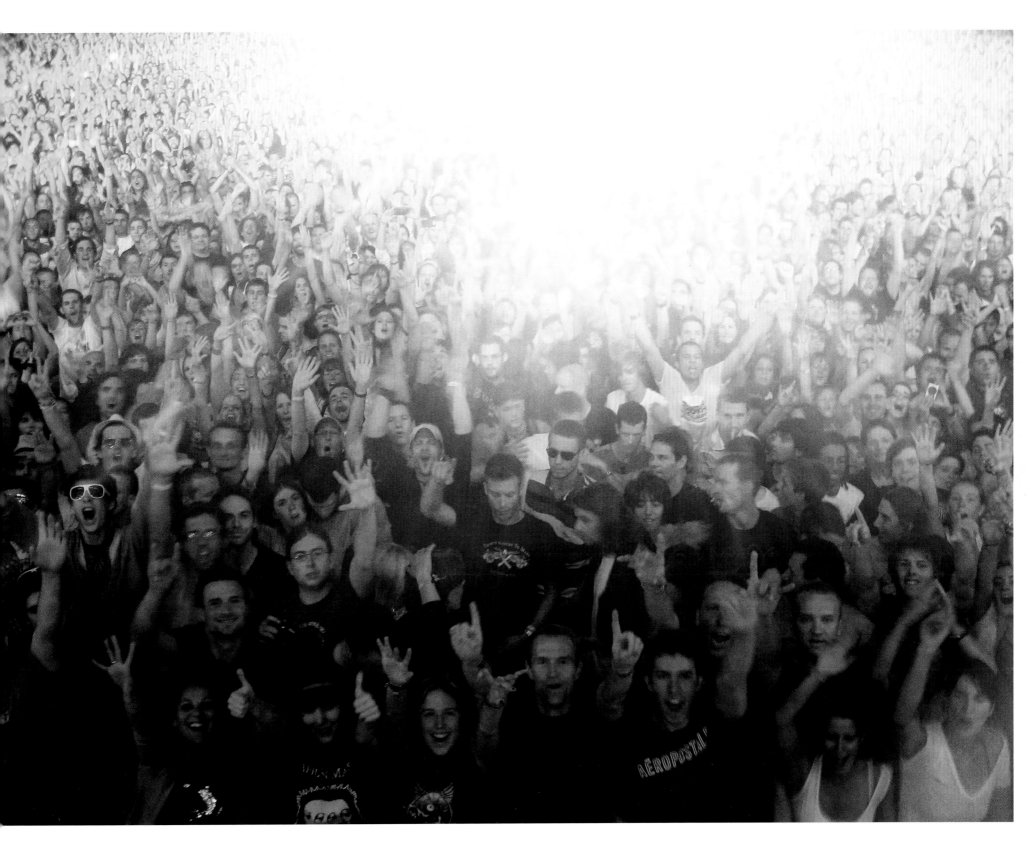

nyc

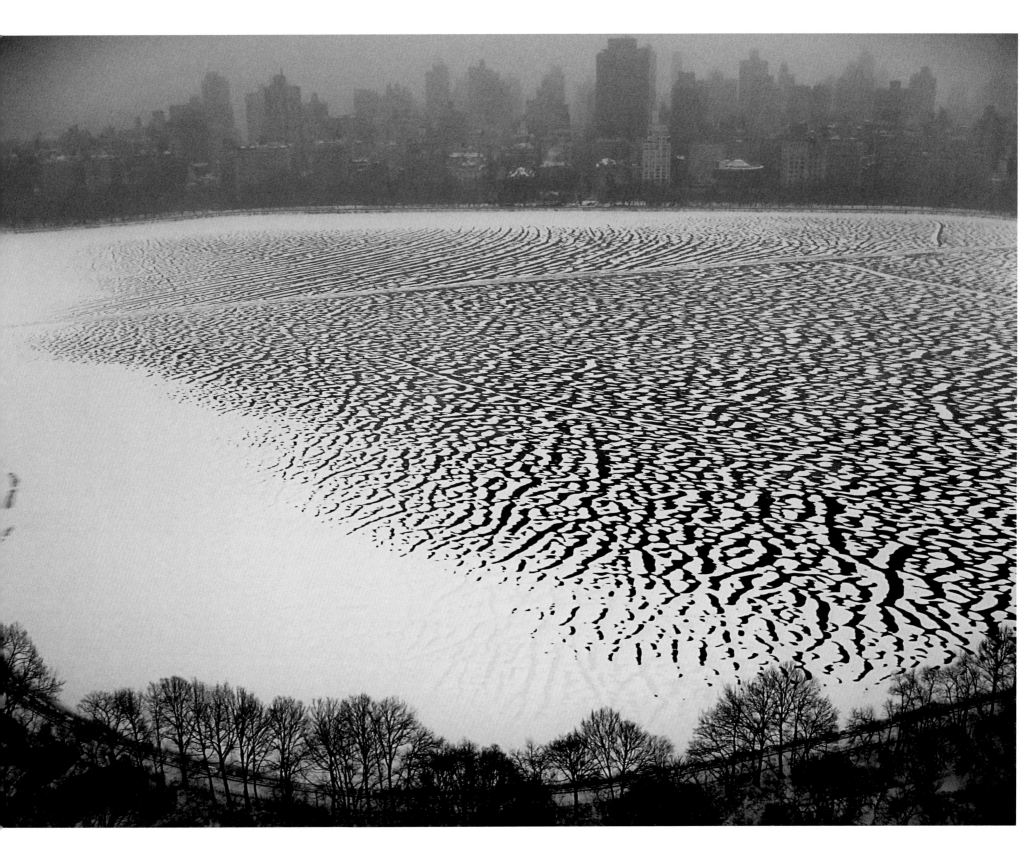

london

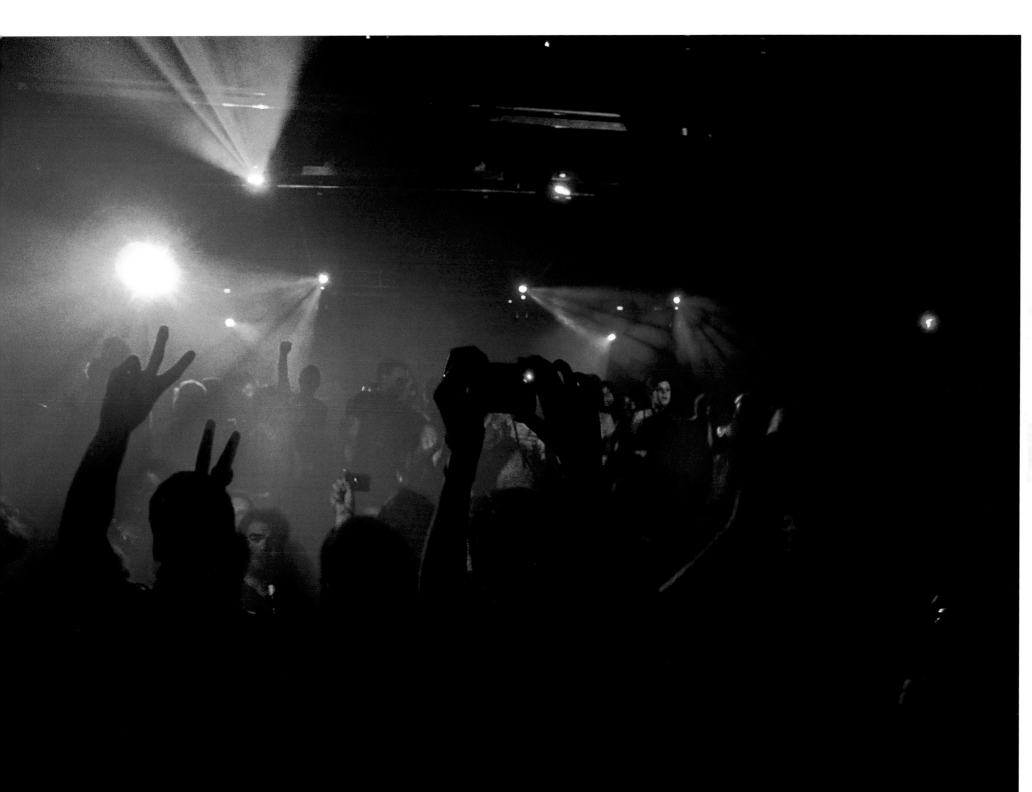

italy

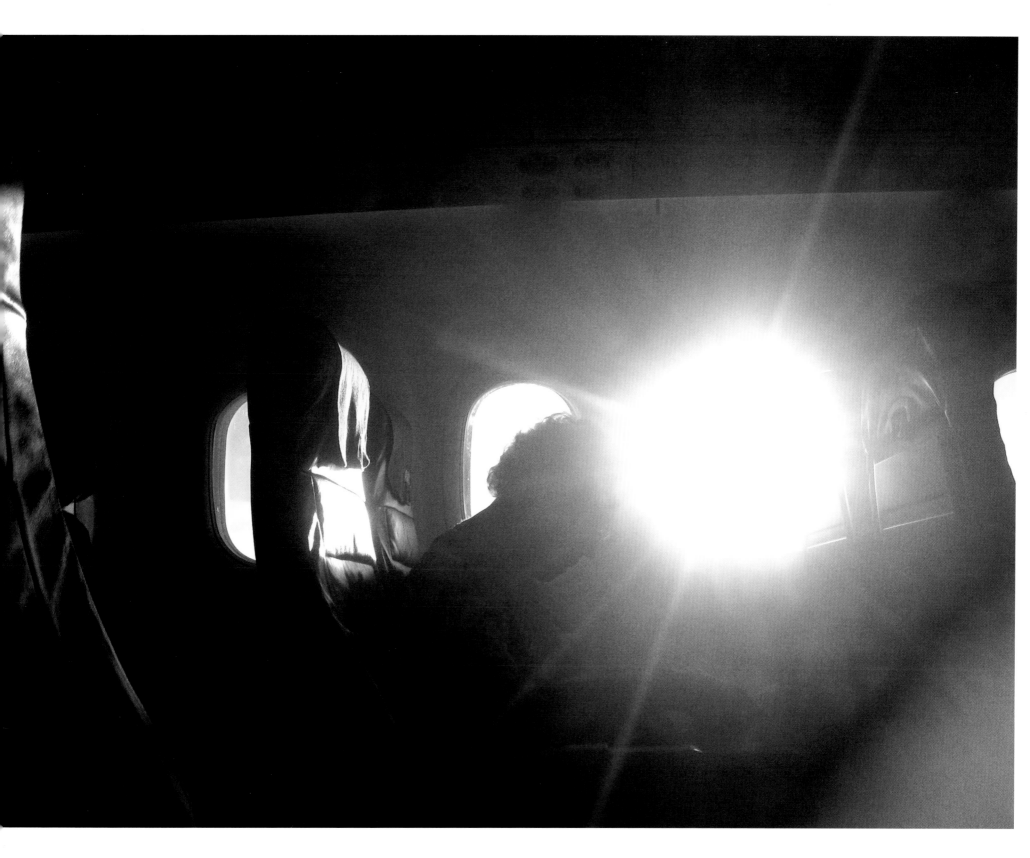

buenos aires

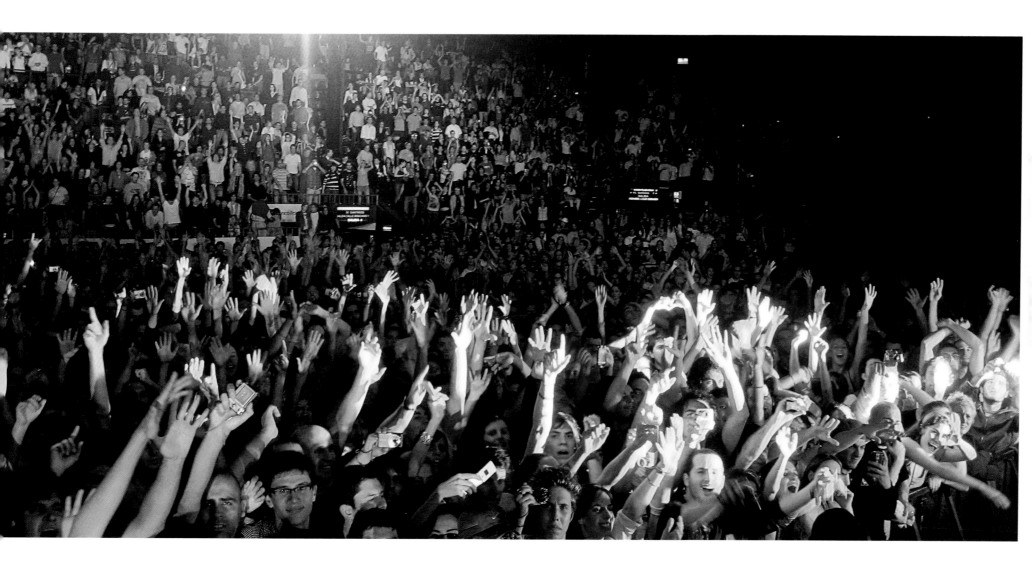

english channel

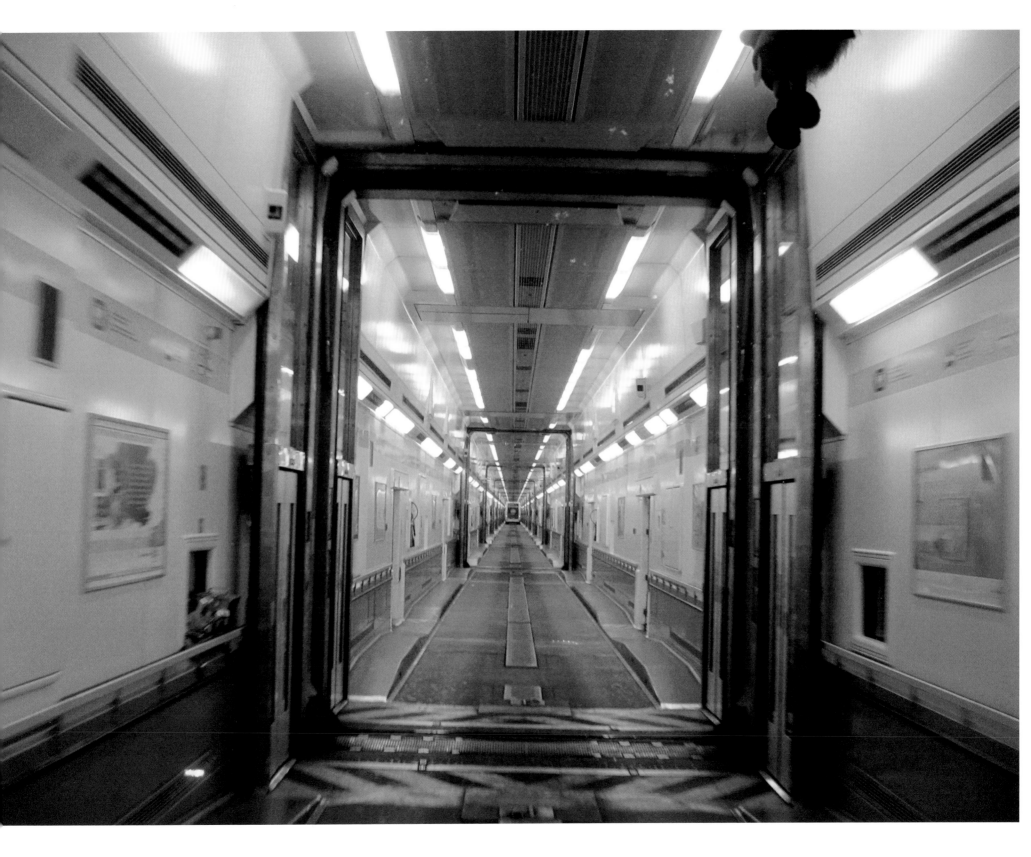

sumatra

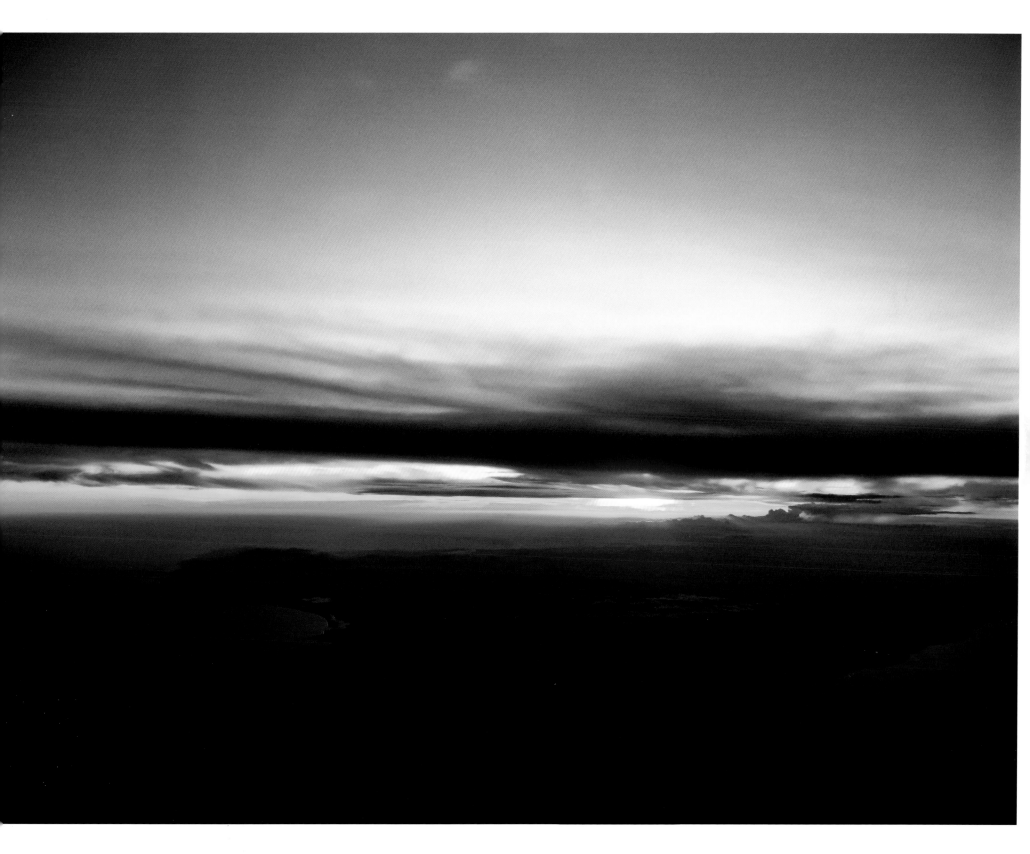

lausanne

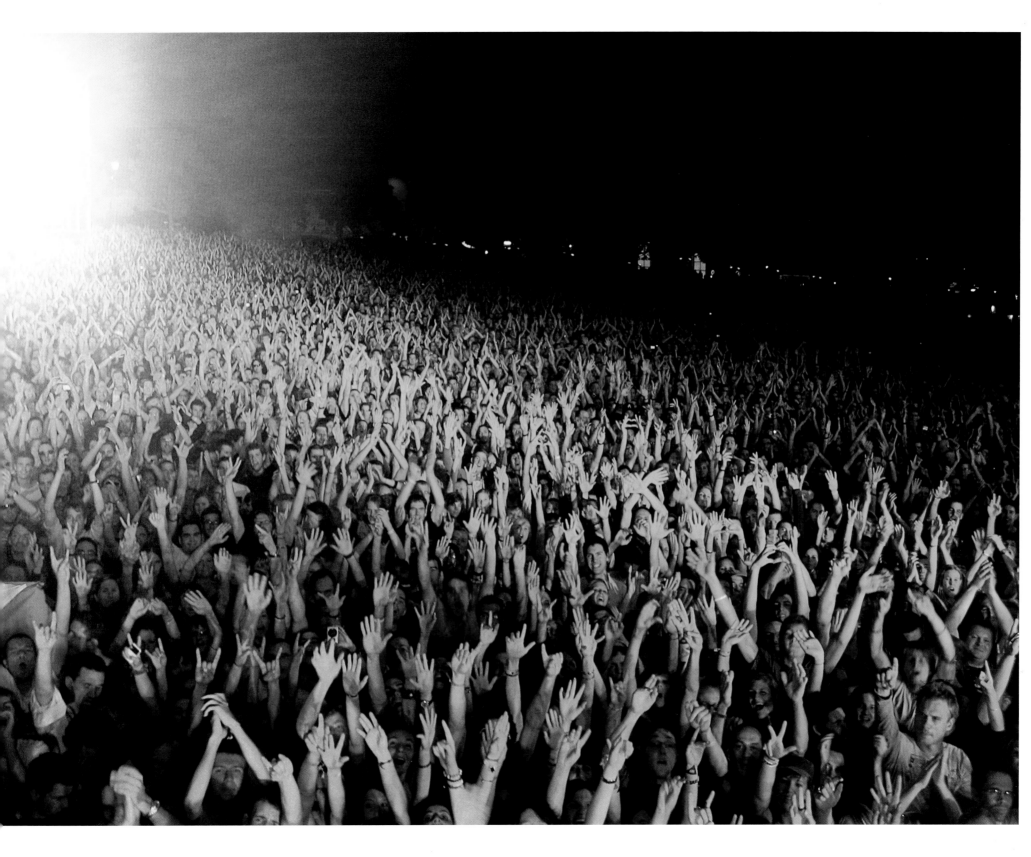

vienna

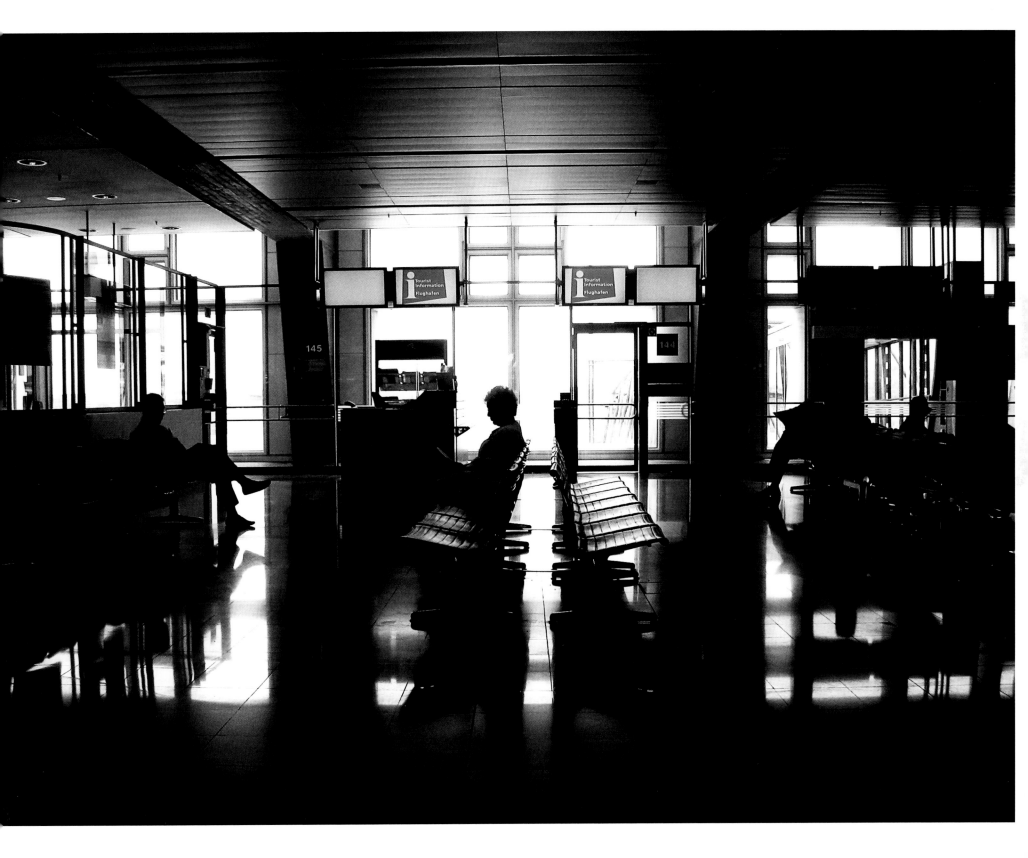

minnesota

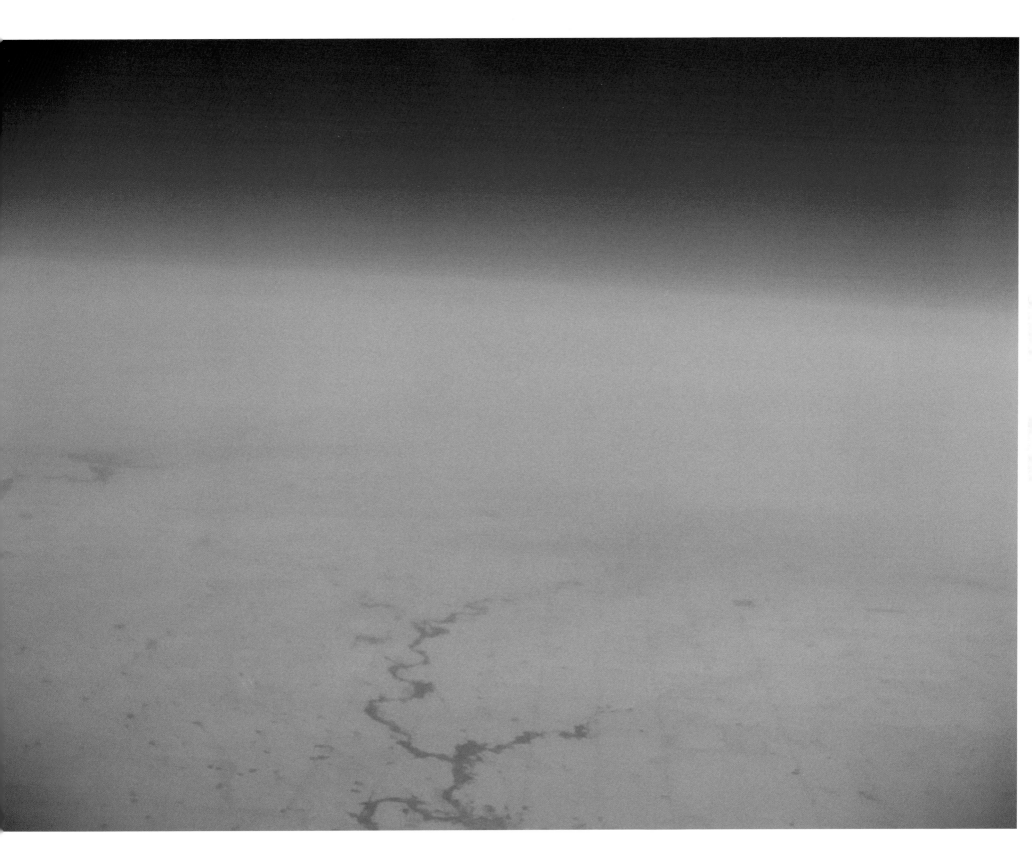

barcelona

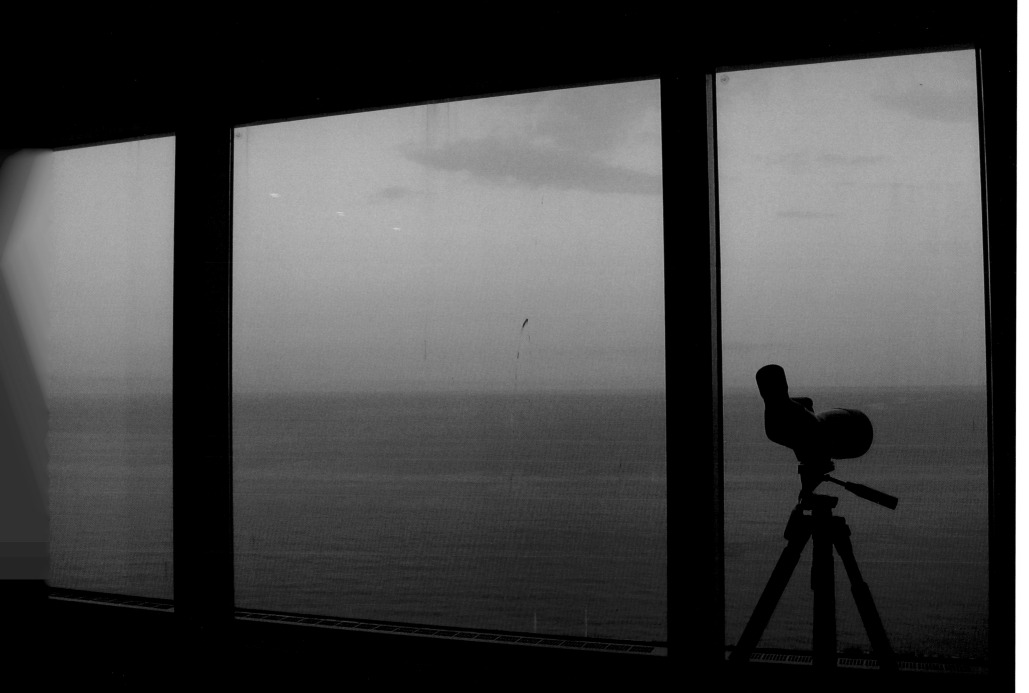

paris

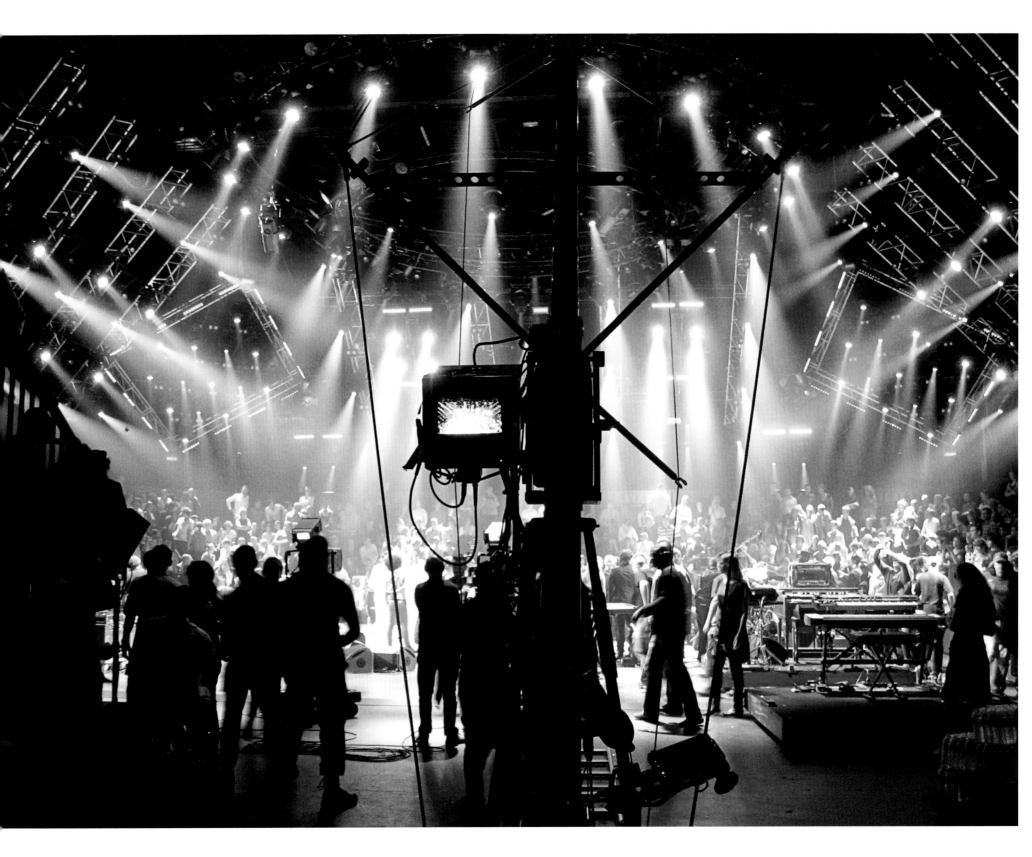

koln

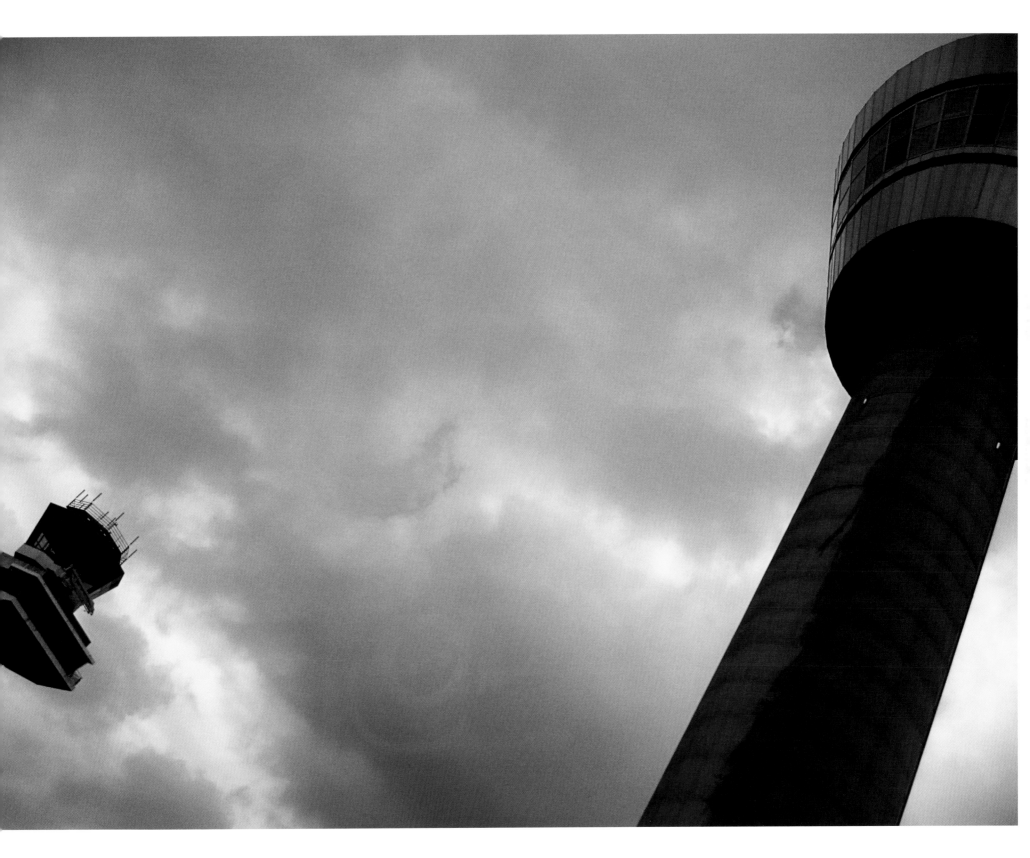

brisbane

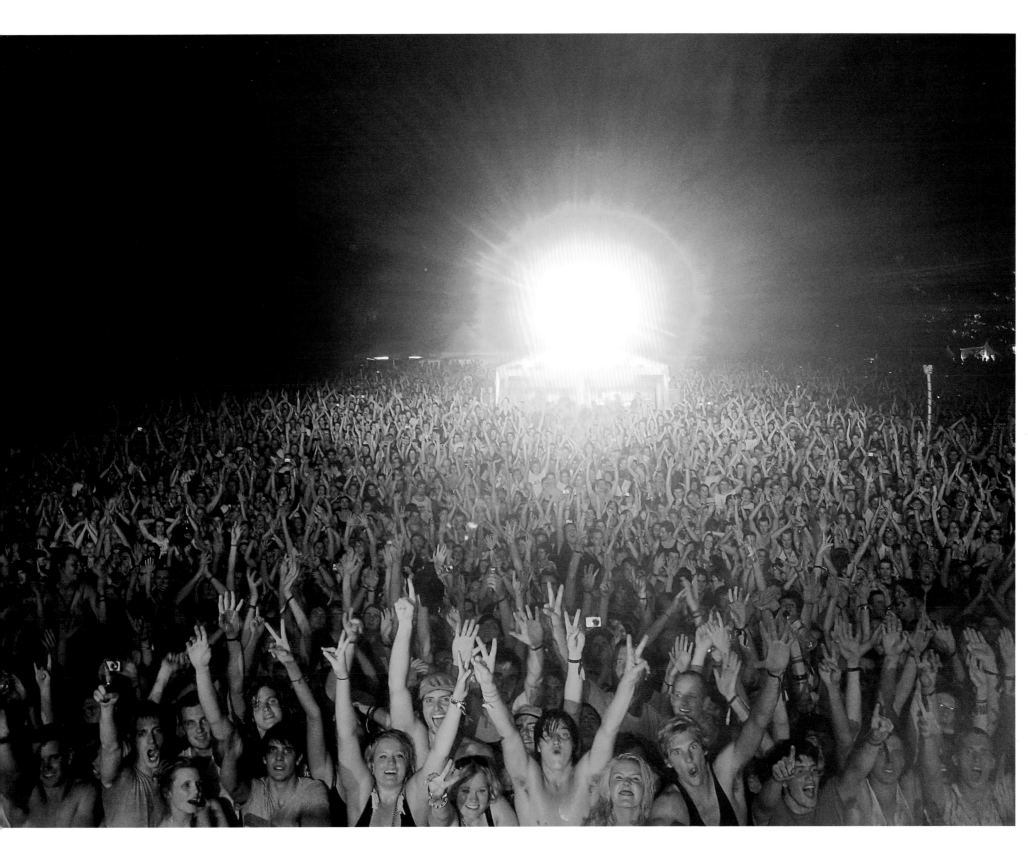

paris

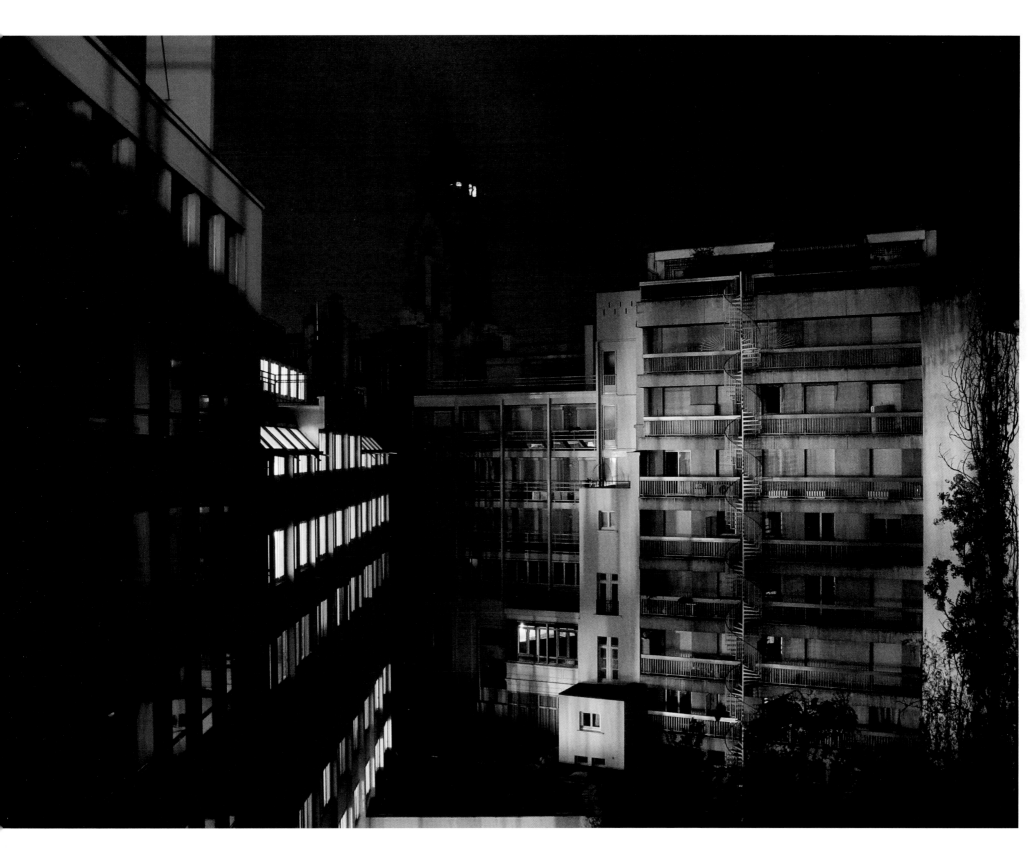

iowa

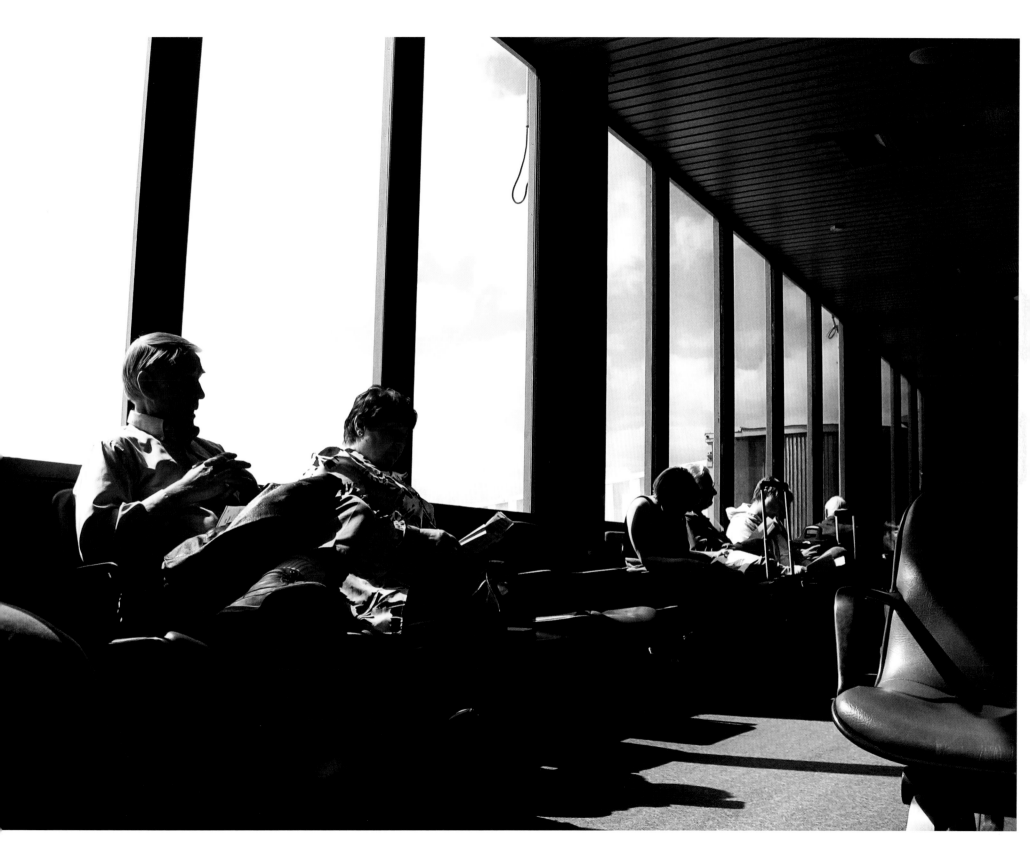

prague

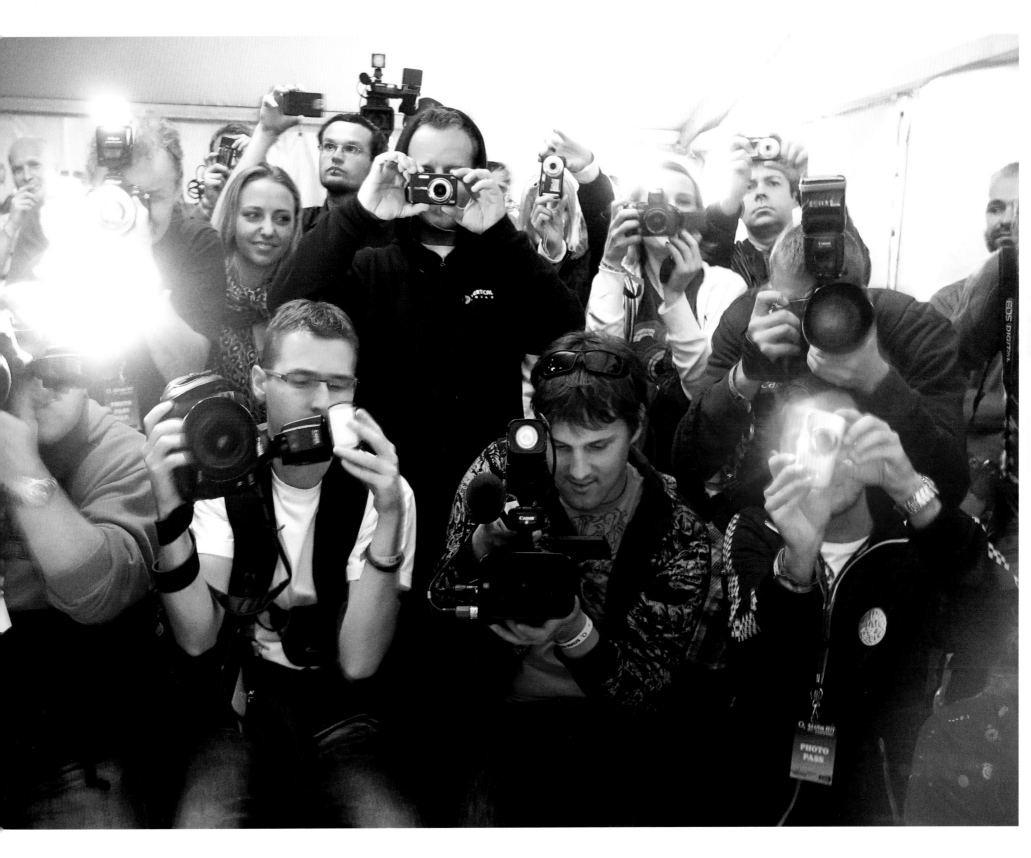

london

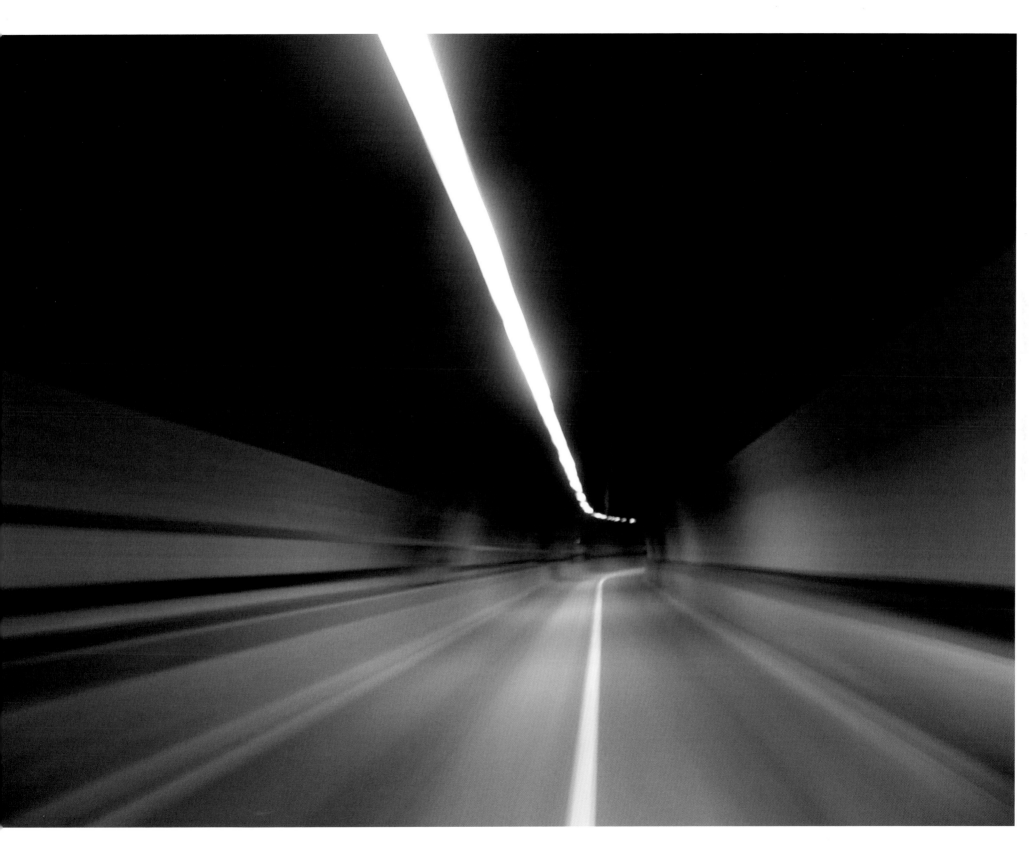

belgium

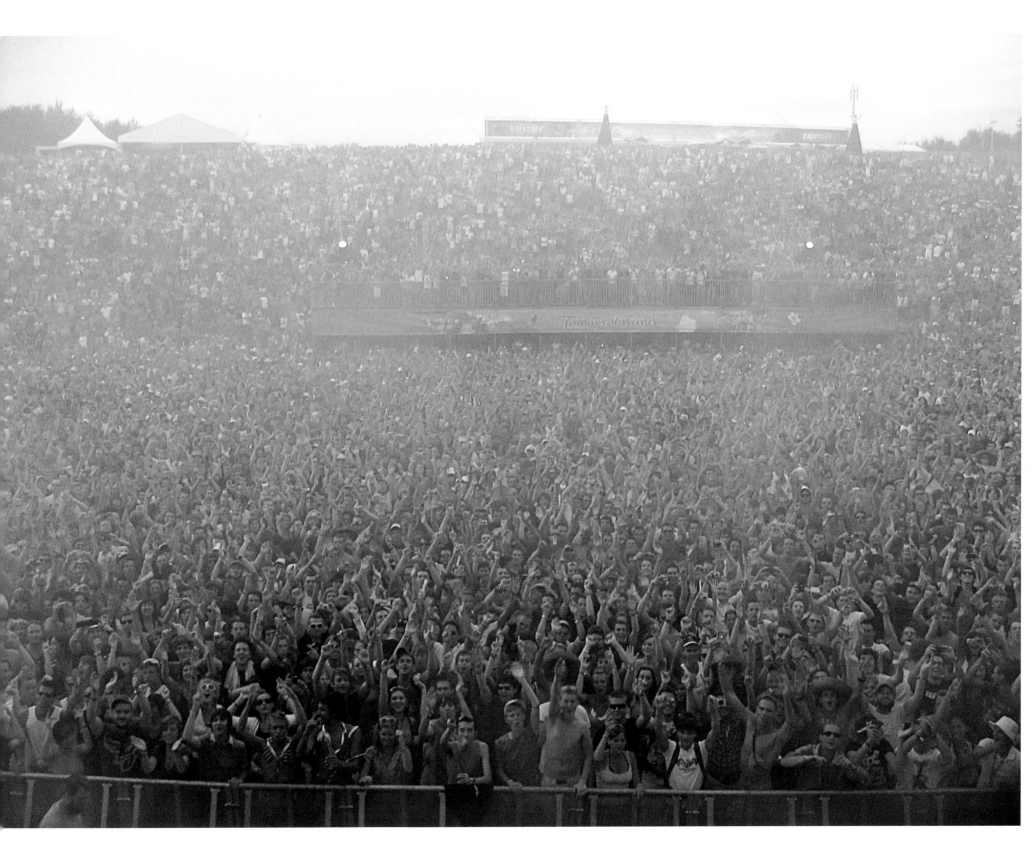

luxembourg

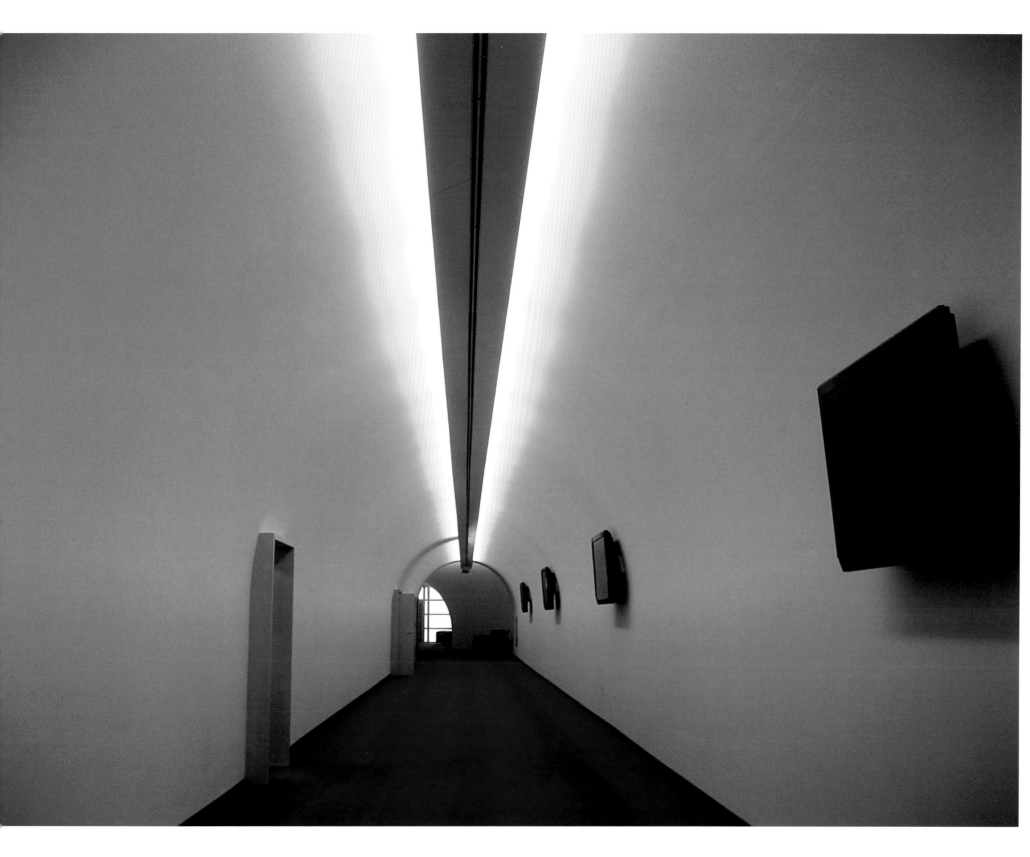

malta

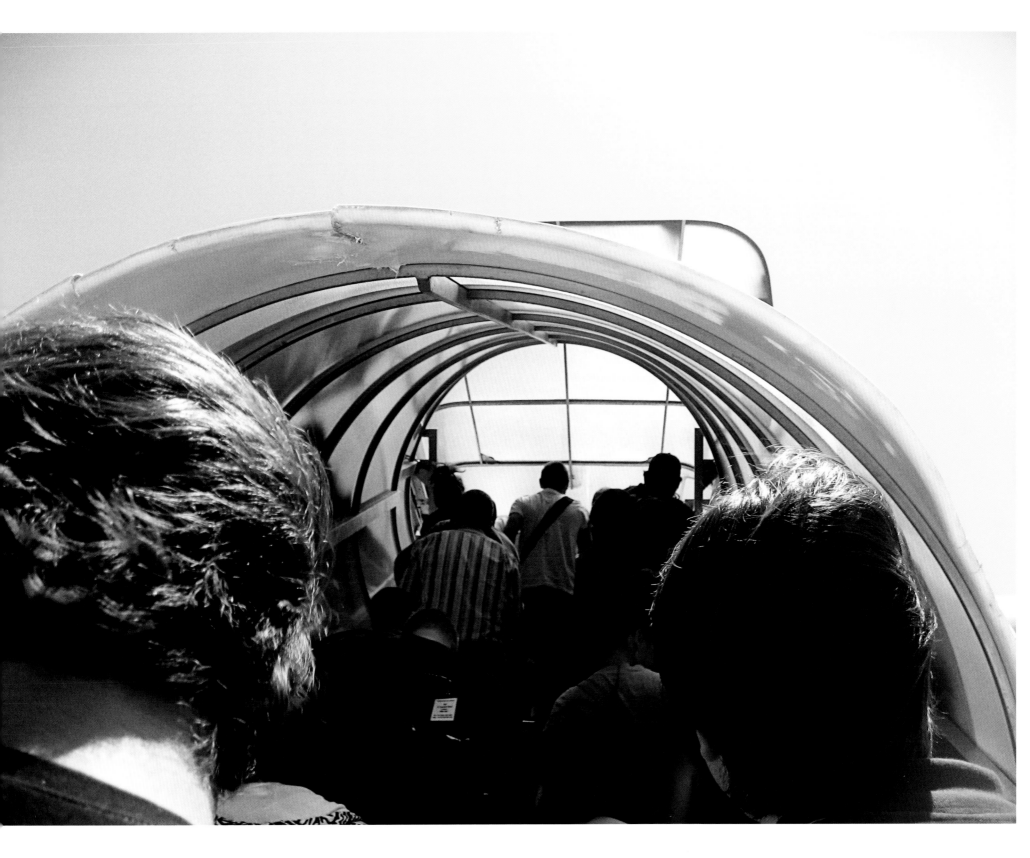

glasgow

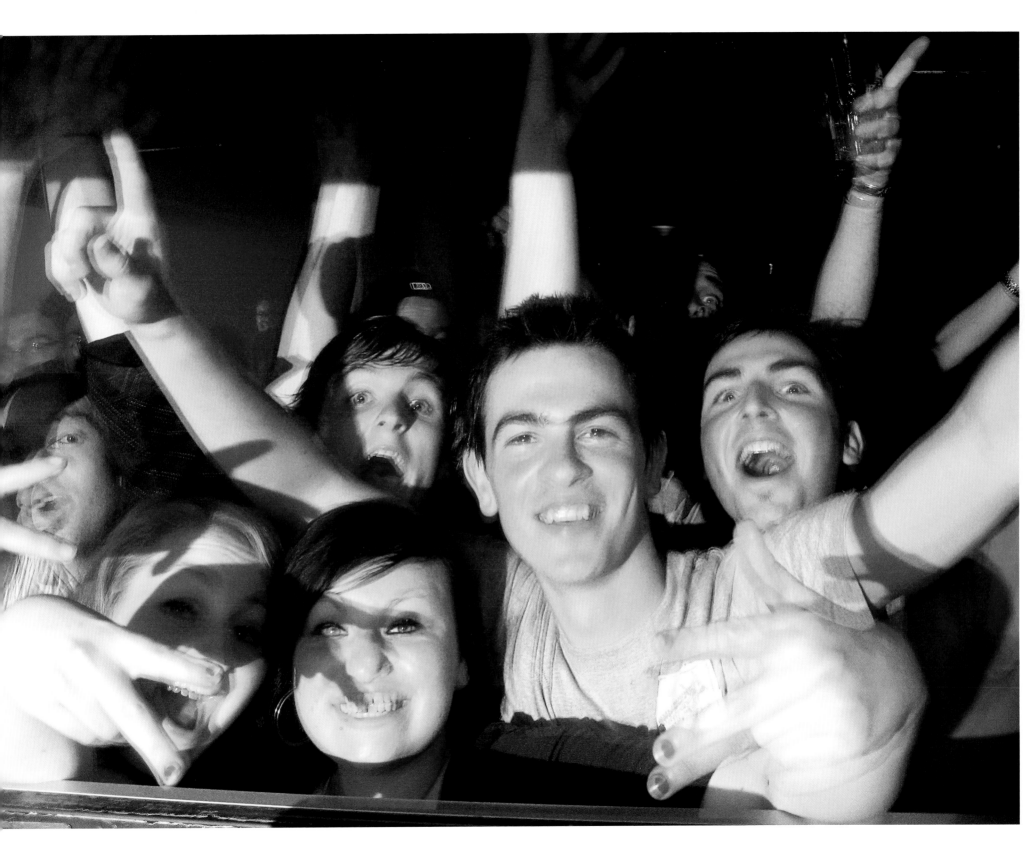

budapest

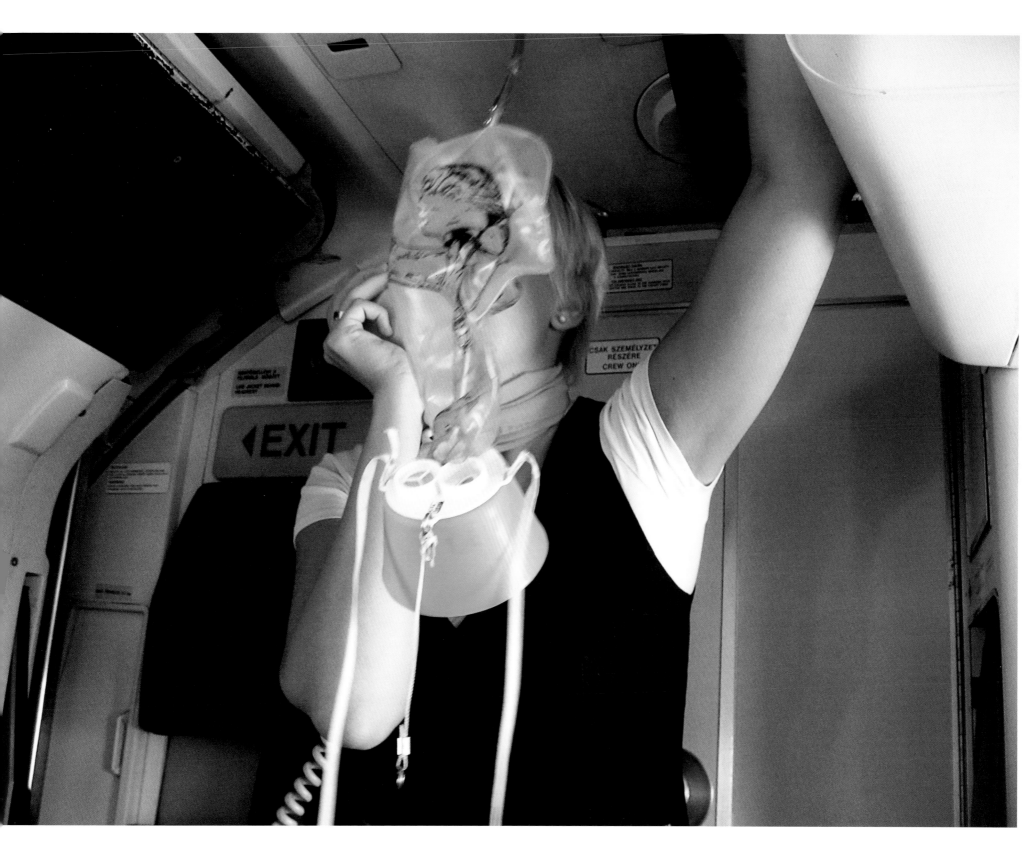

brasilia

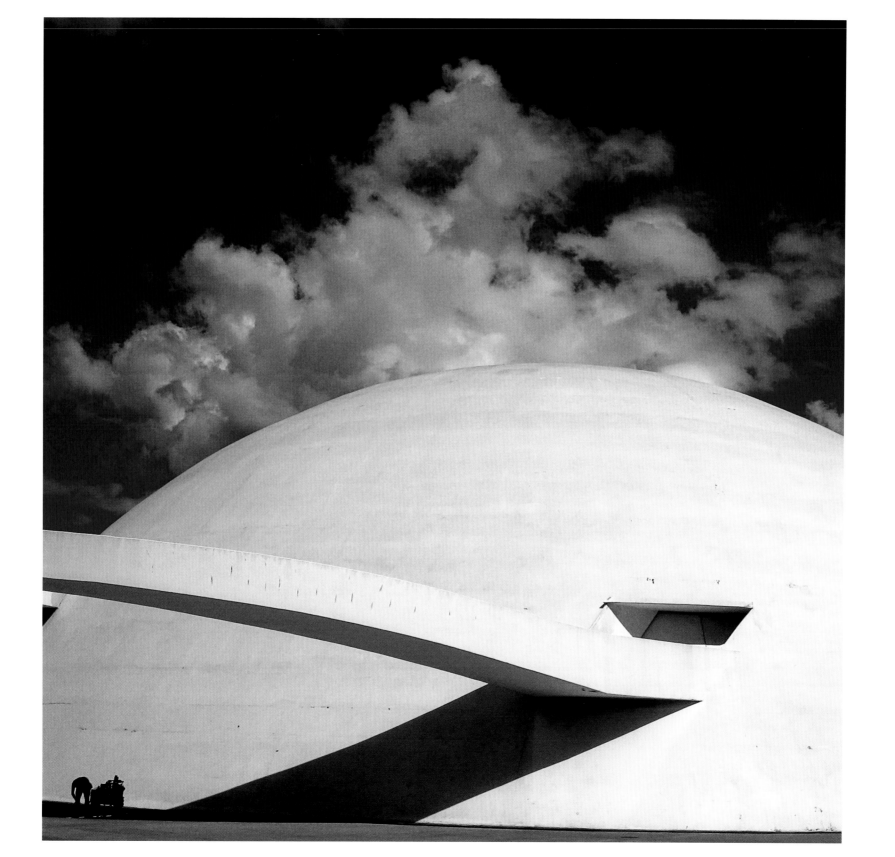

melbourne

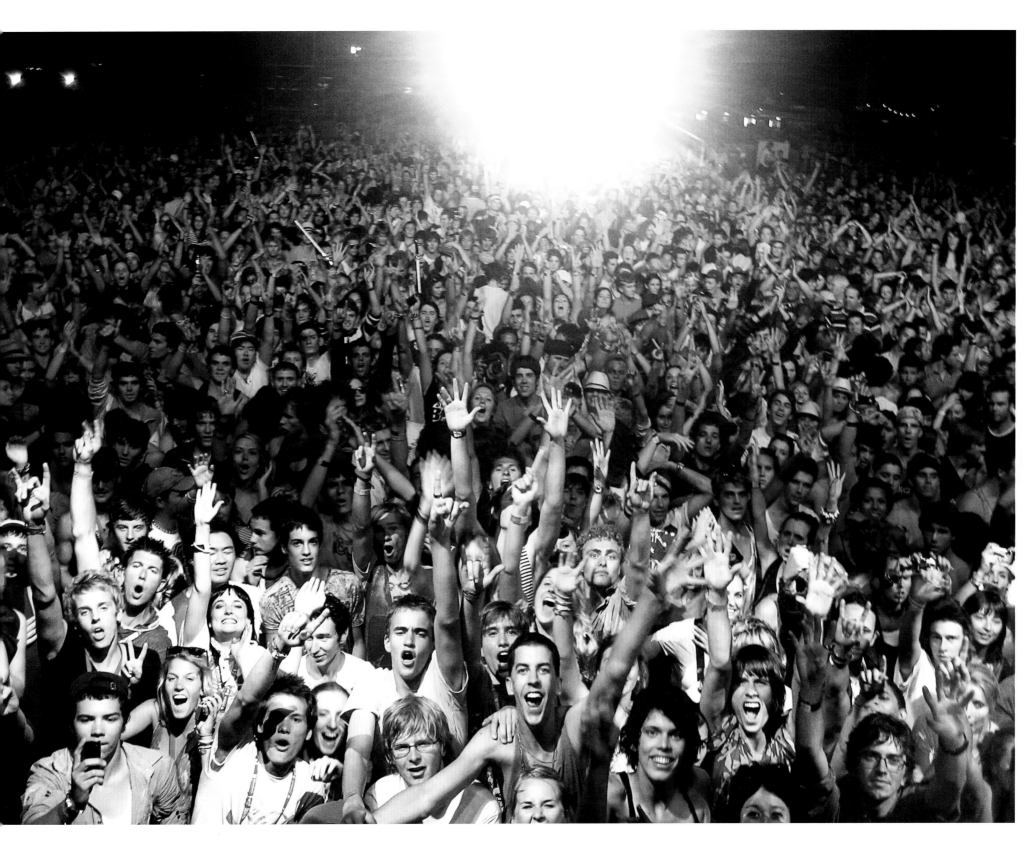

long island sound

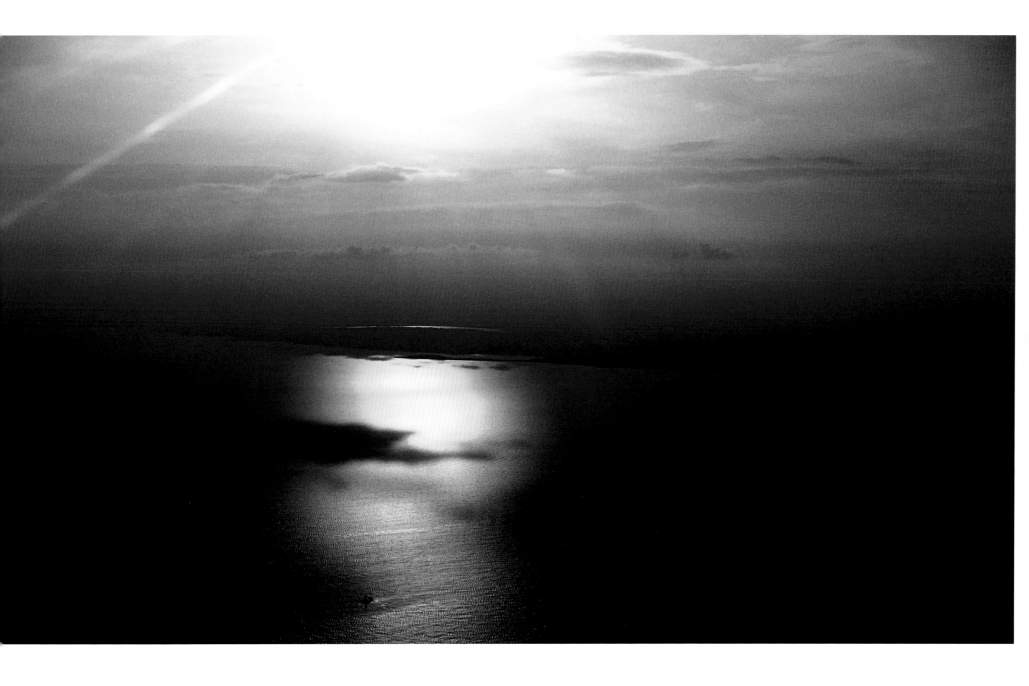

lisbon

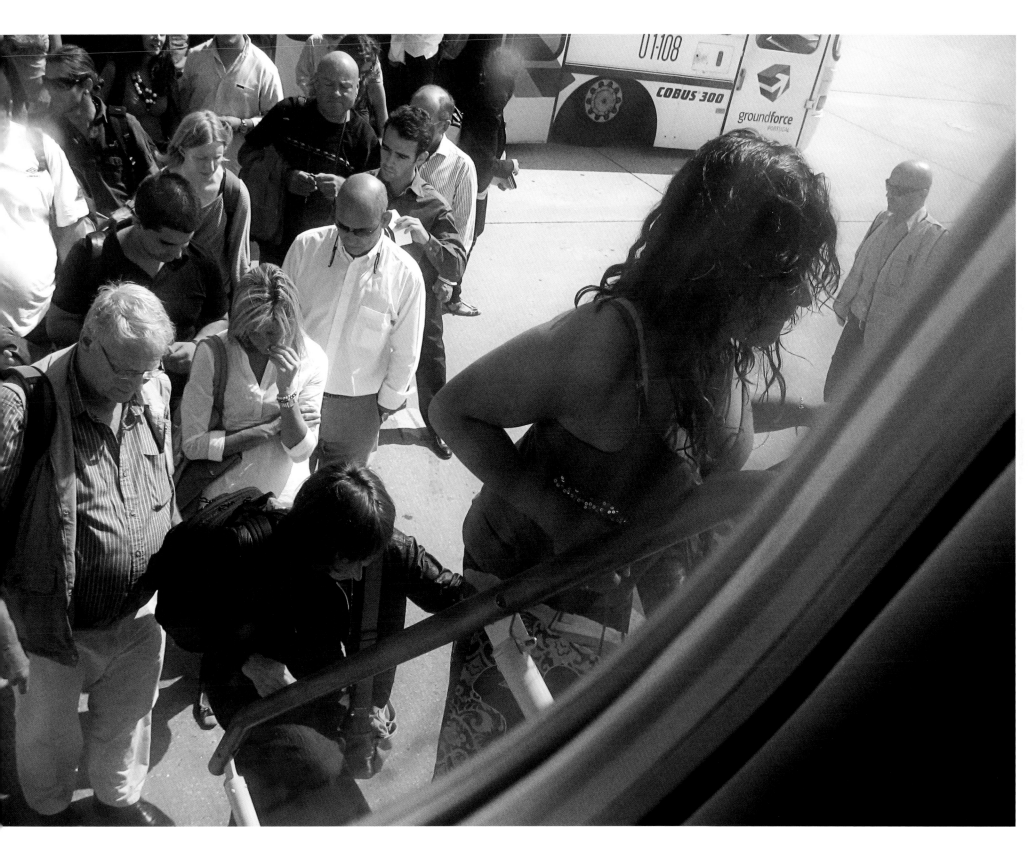

new york

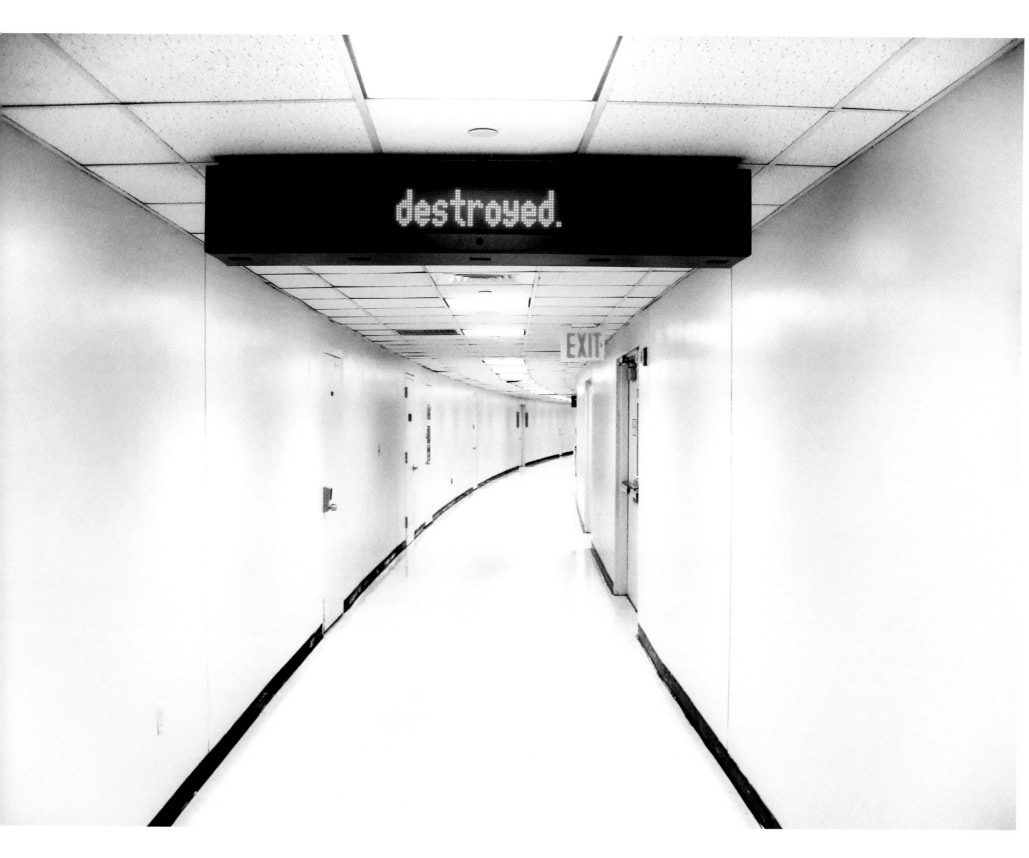

chile

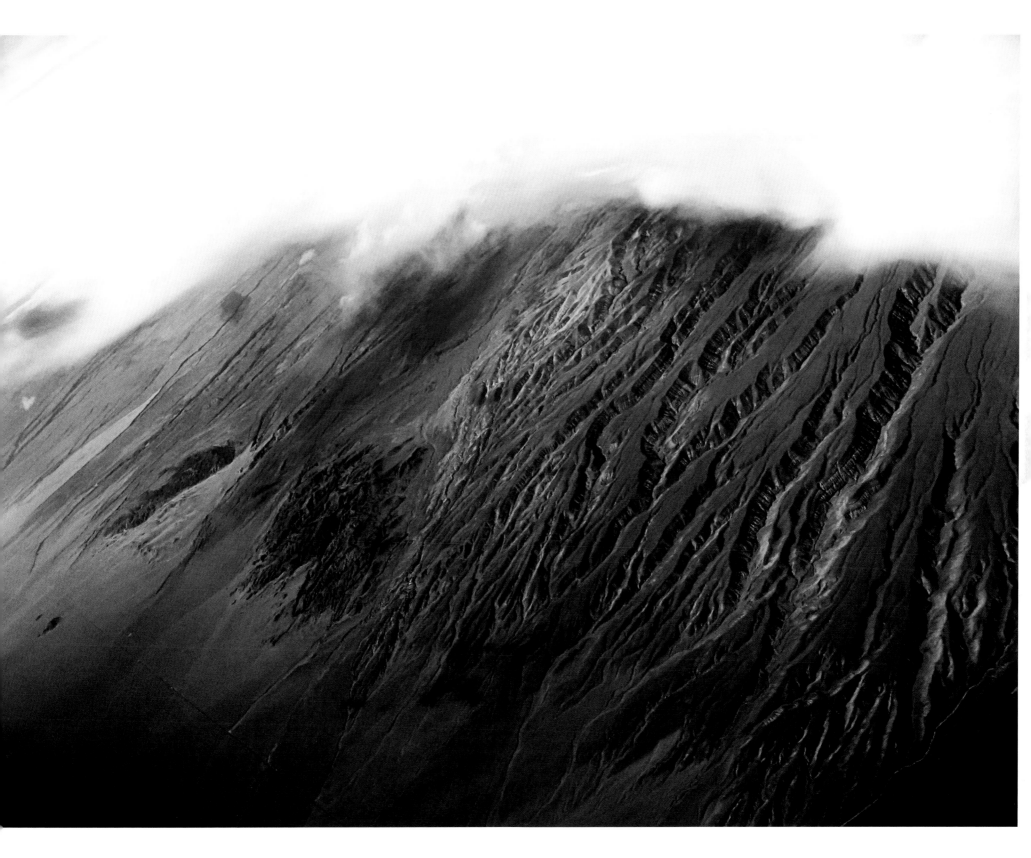

dusseldorf

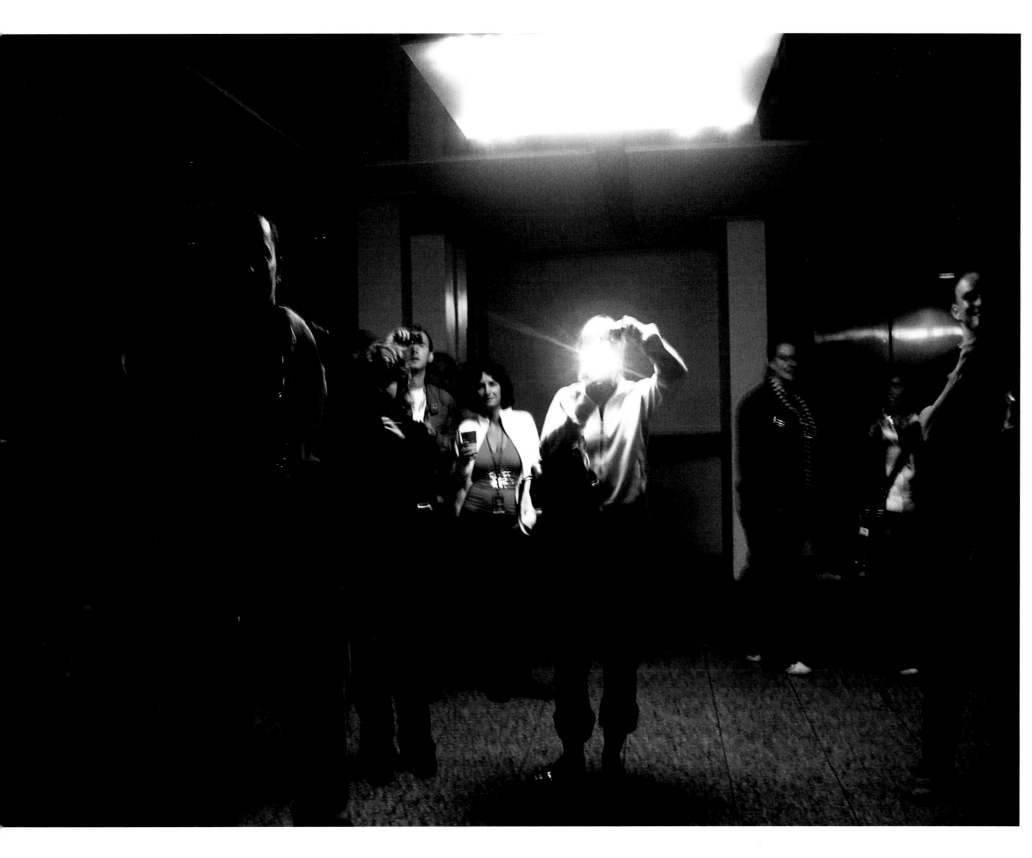

brazil

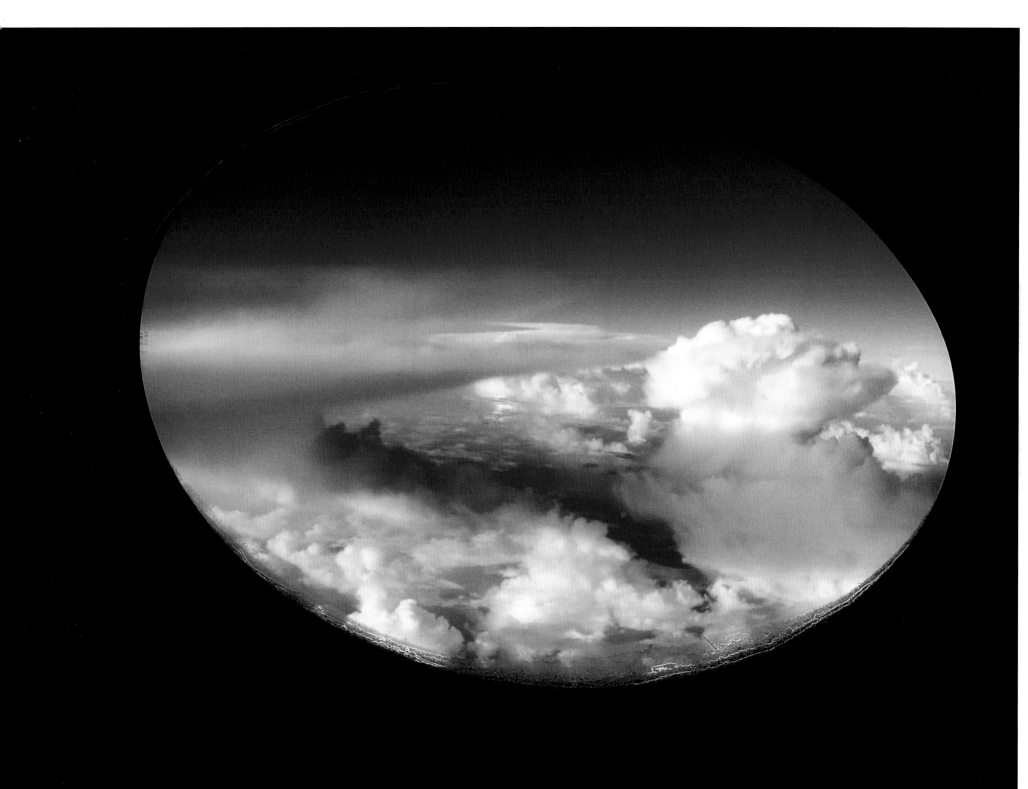

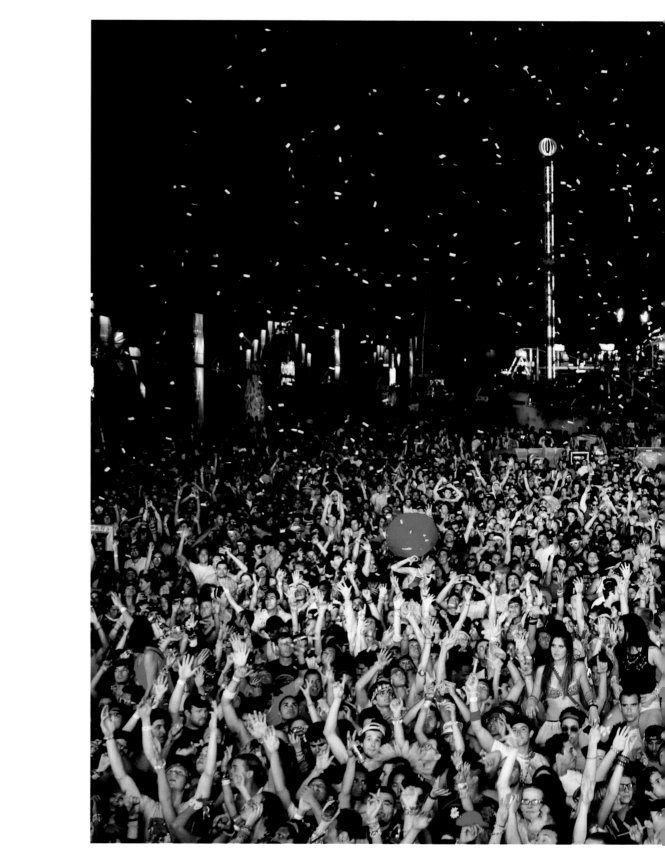

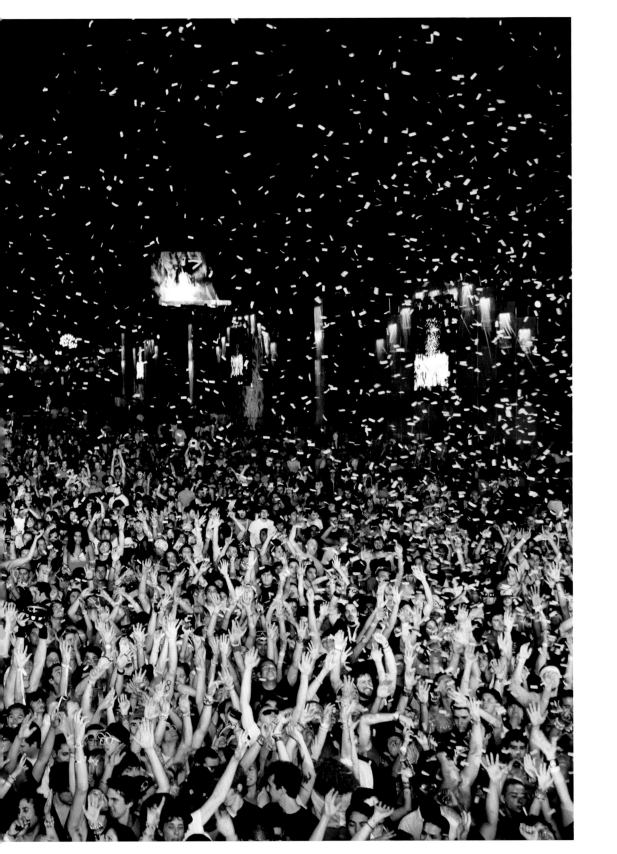

hotel room

« los angeles

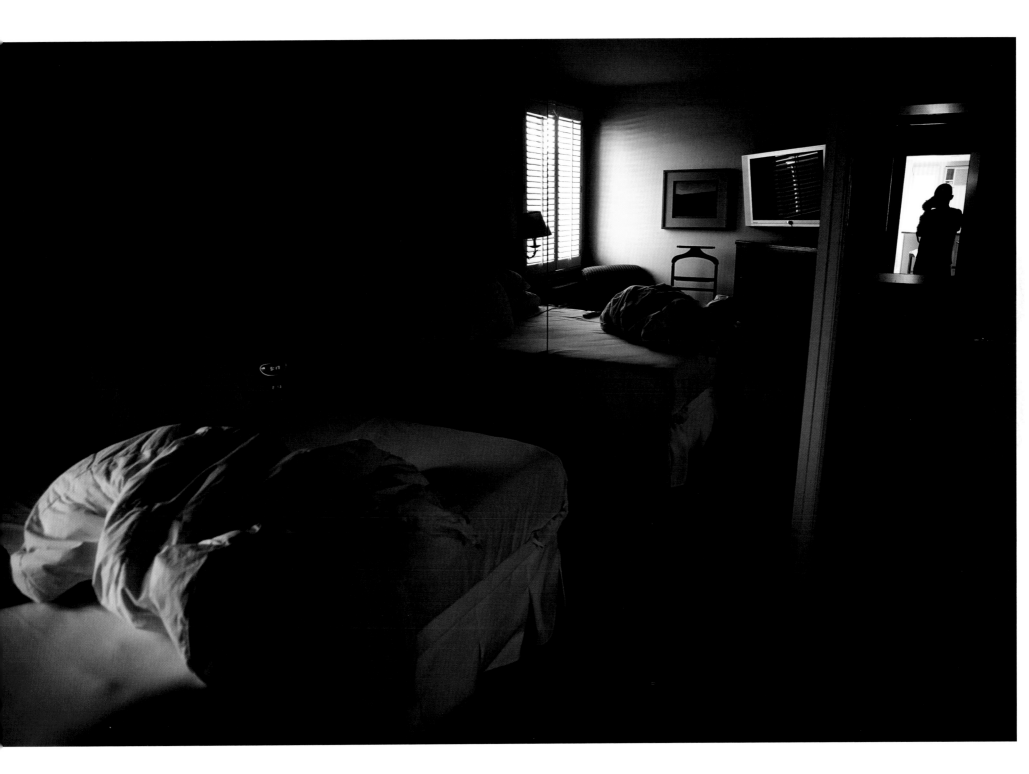

hudson river

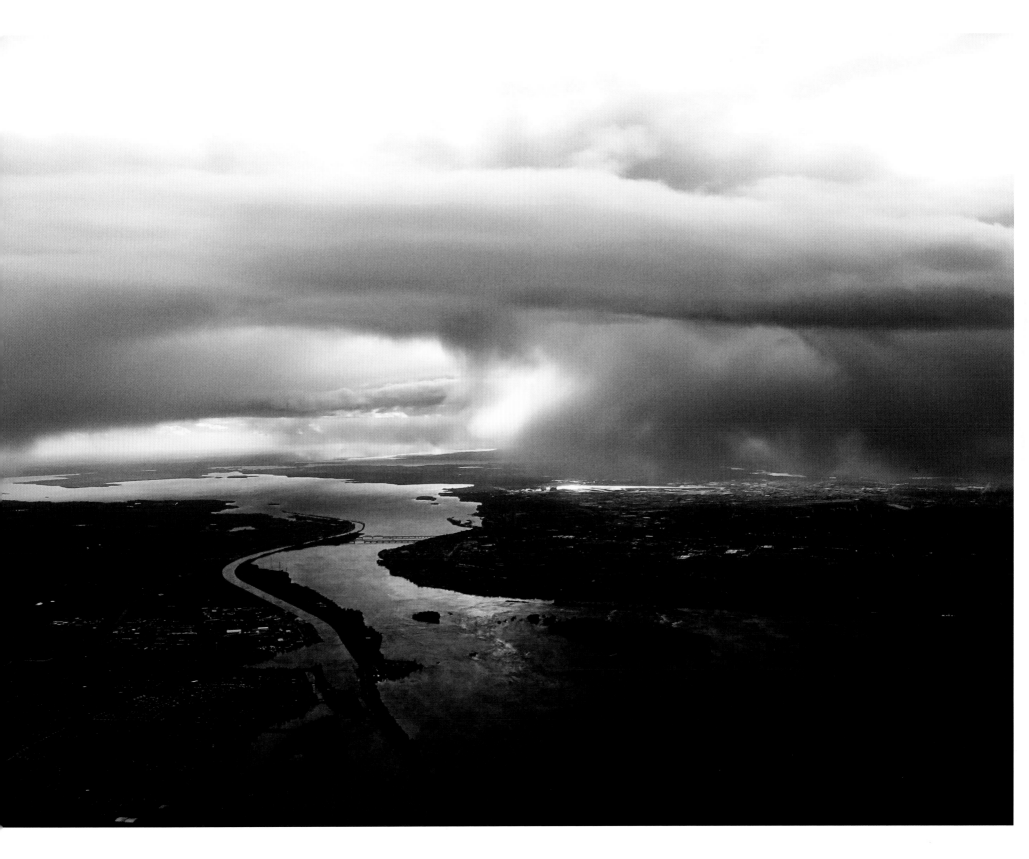

porto allegre

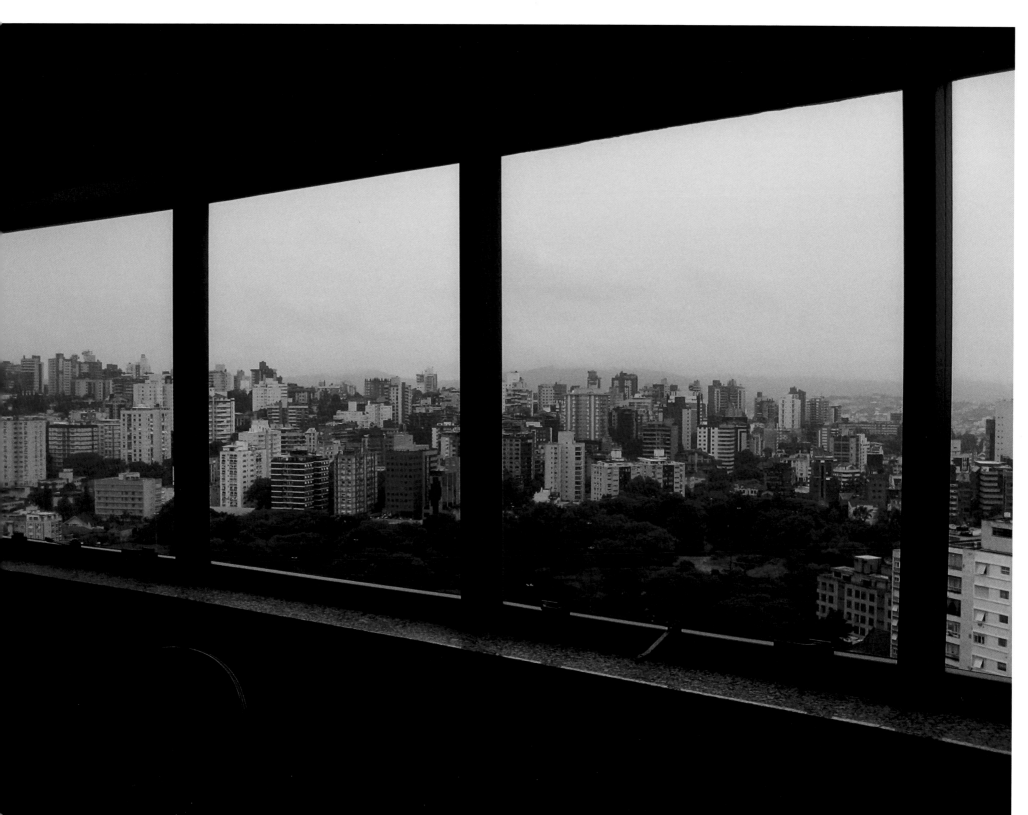

argentina

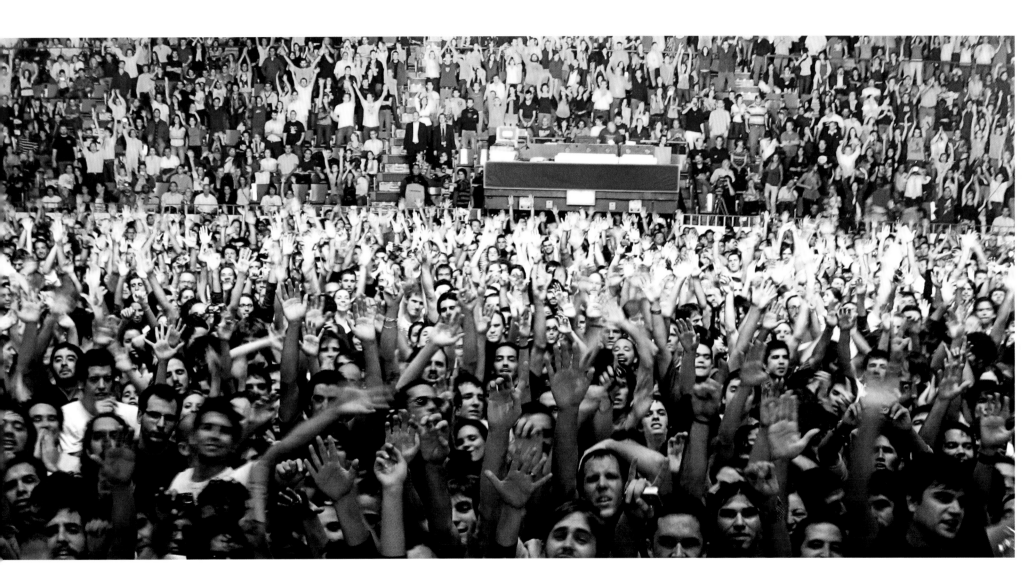

colorado

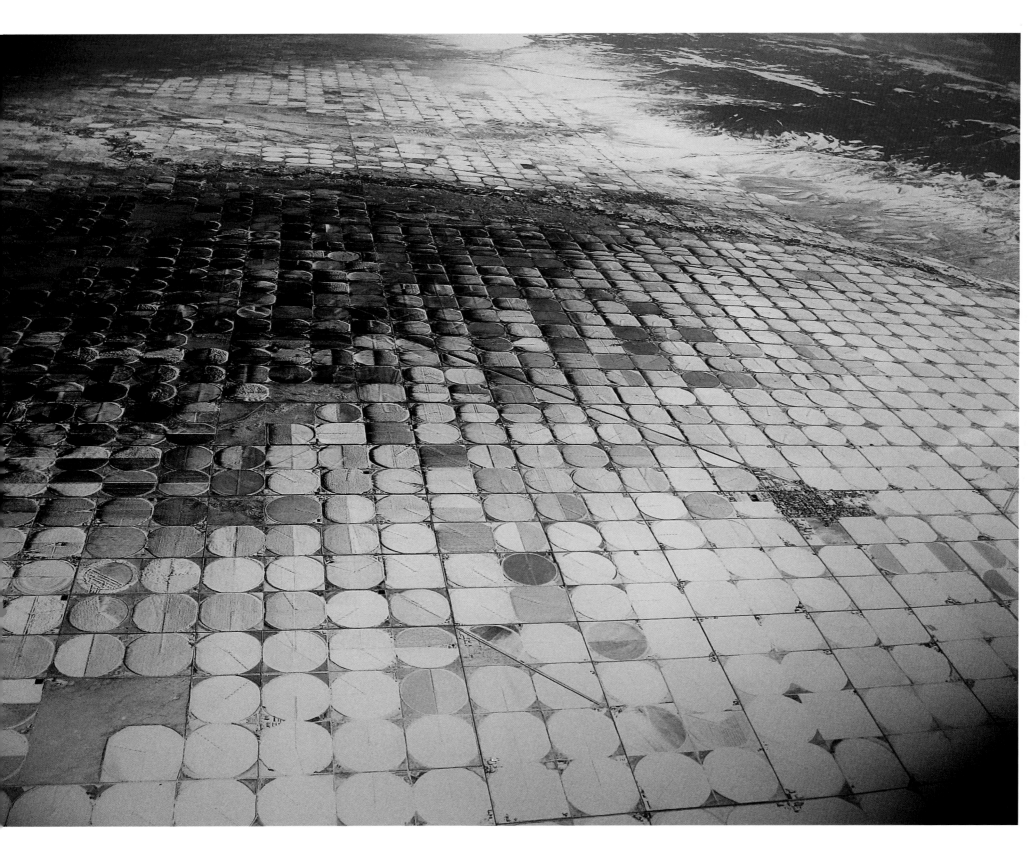

toronto

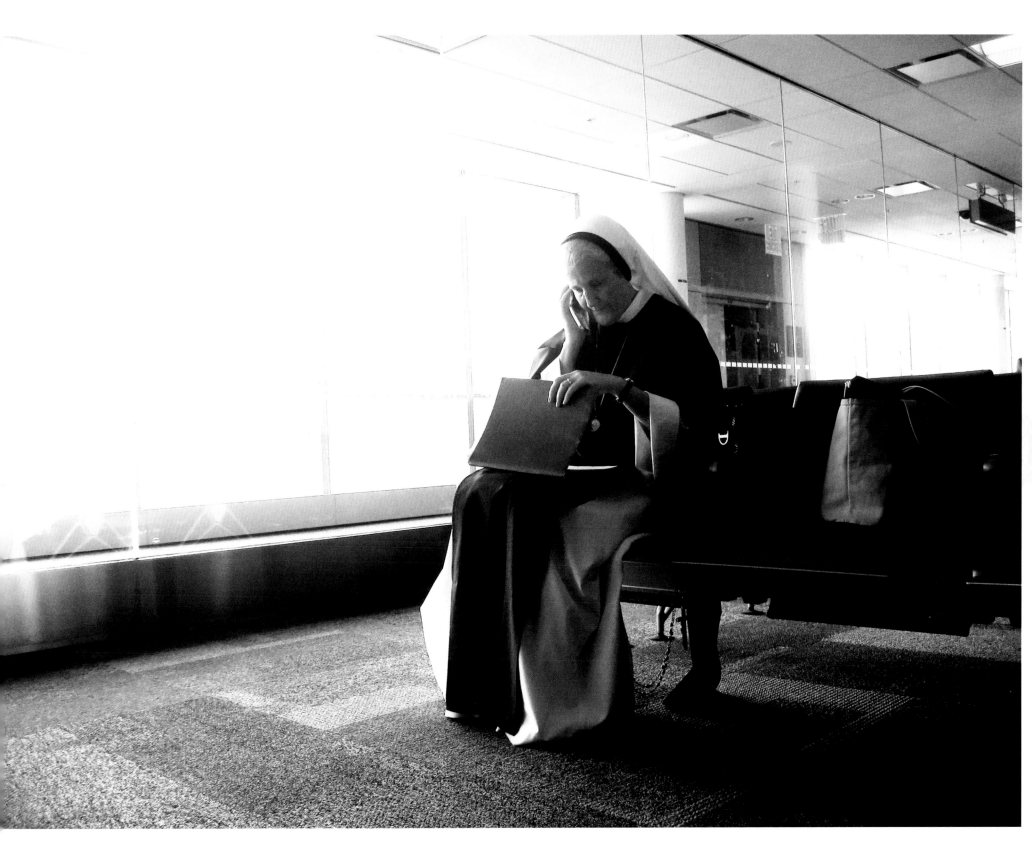

curitiba

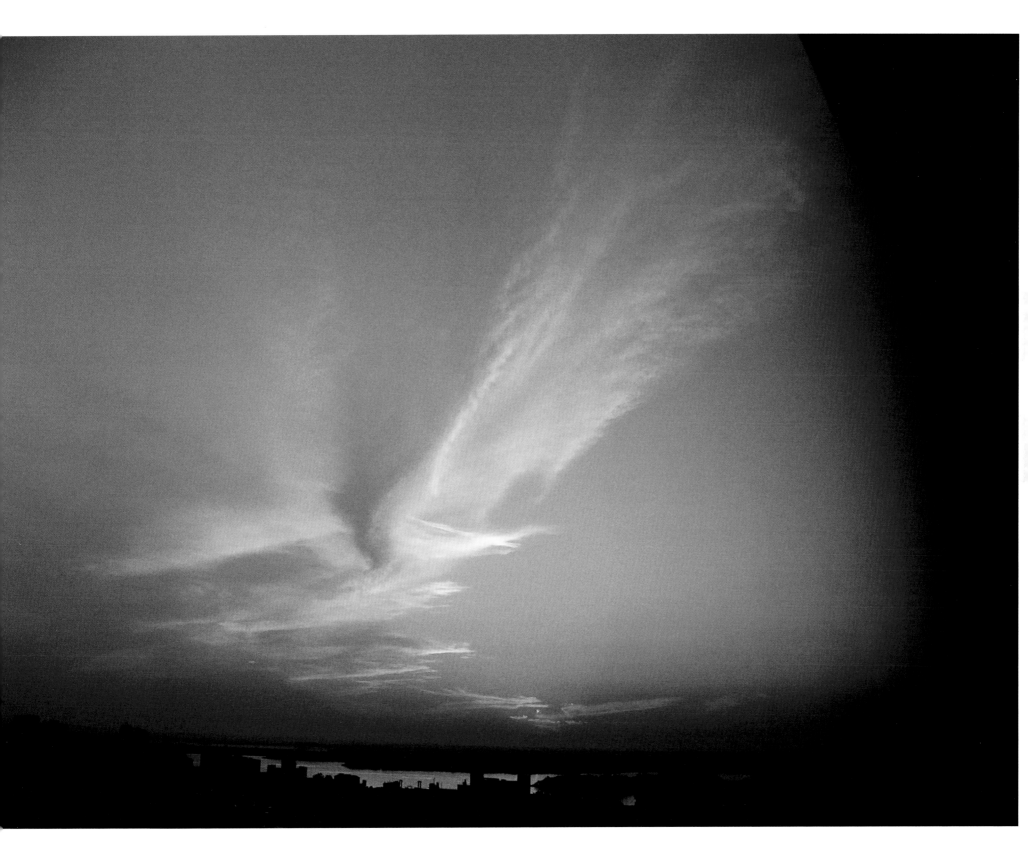

latvia

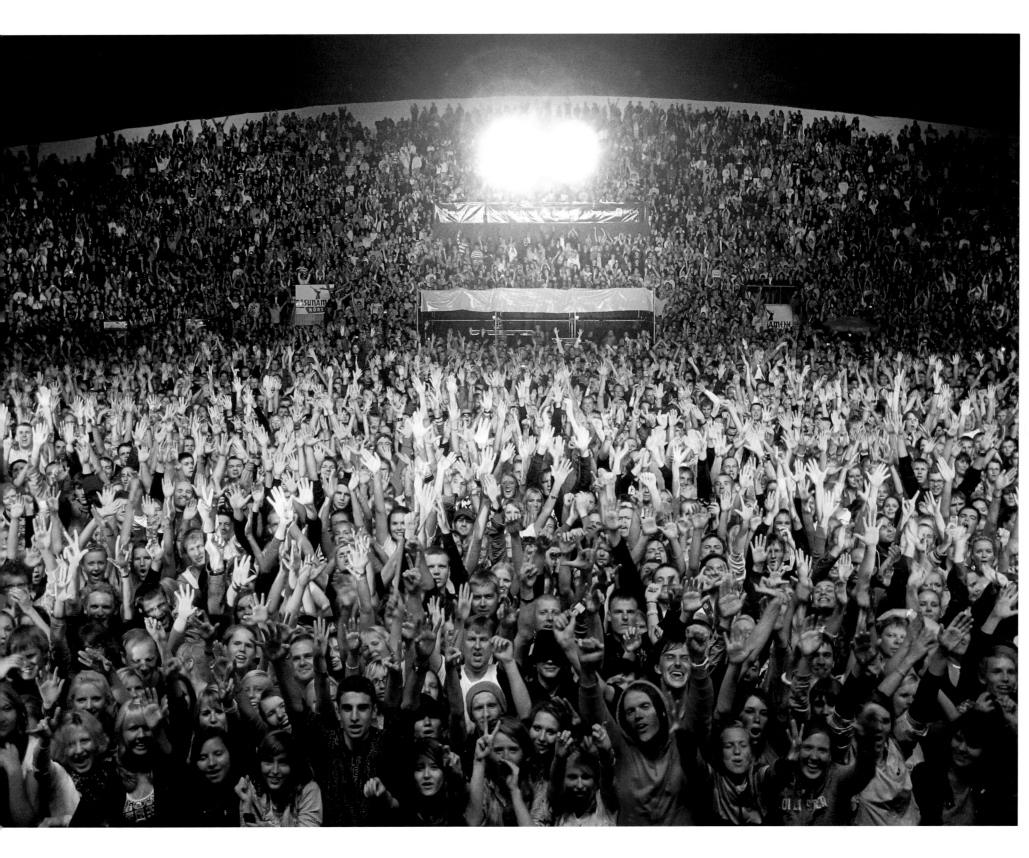

berlin

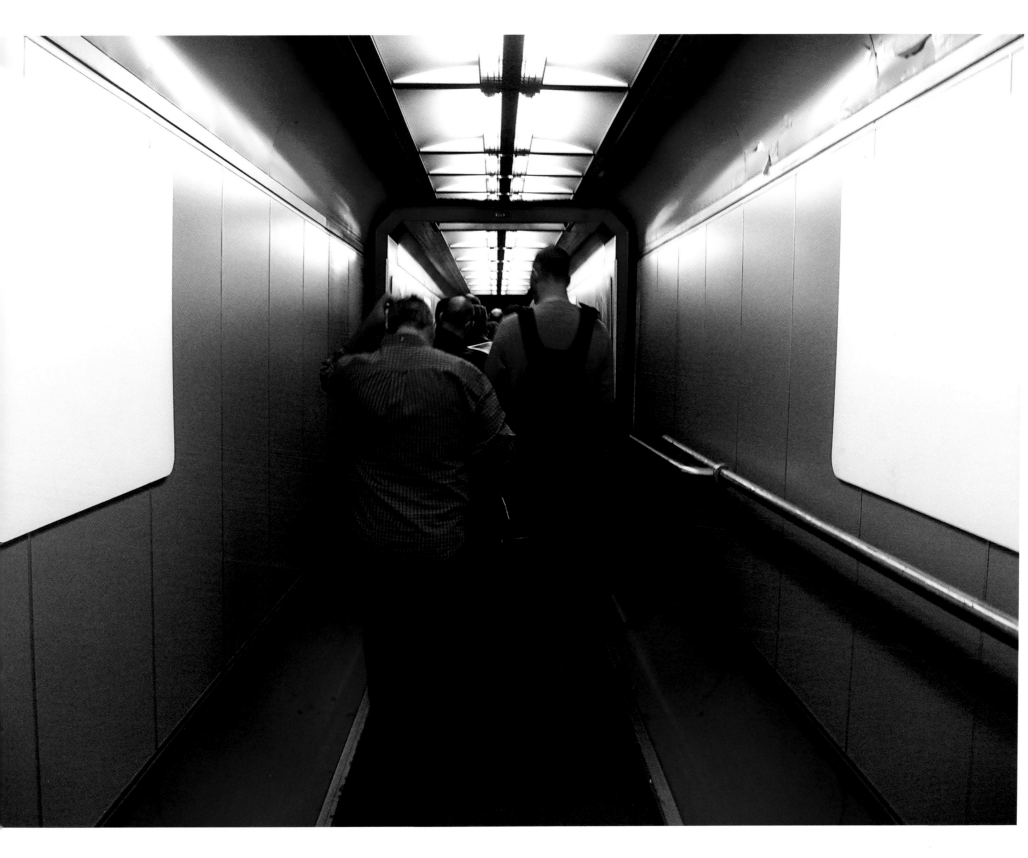

chicago

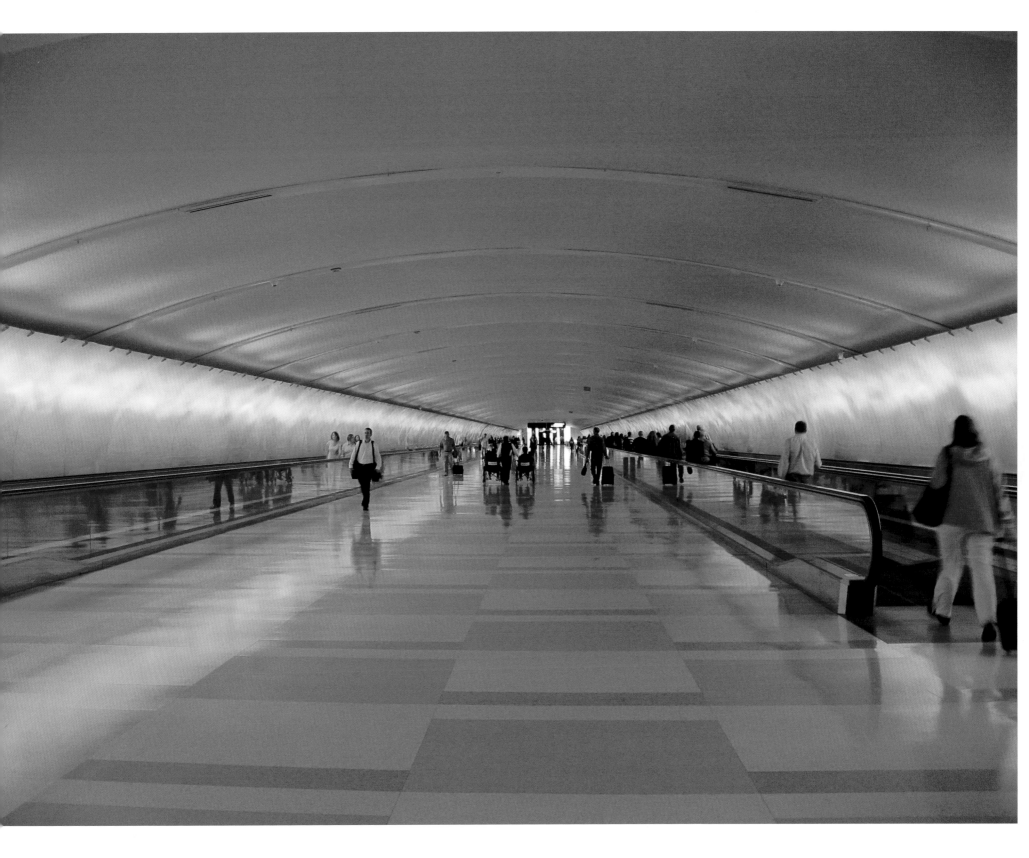

new york

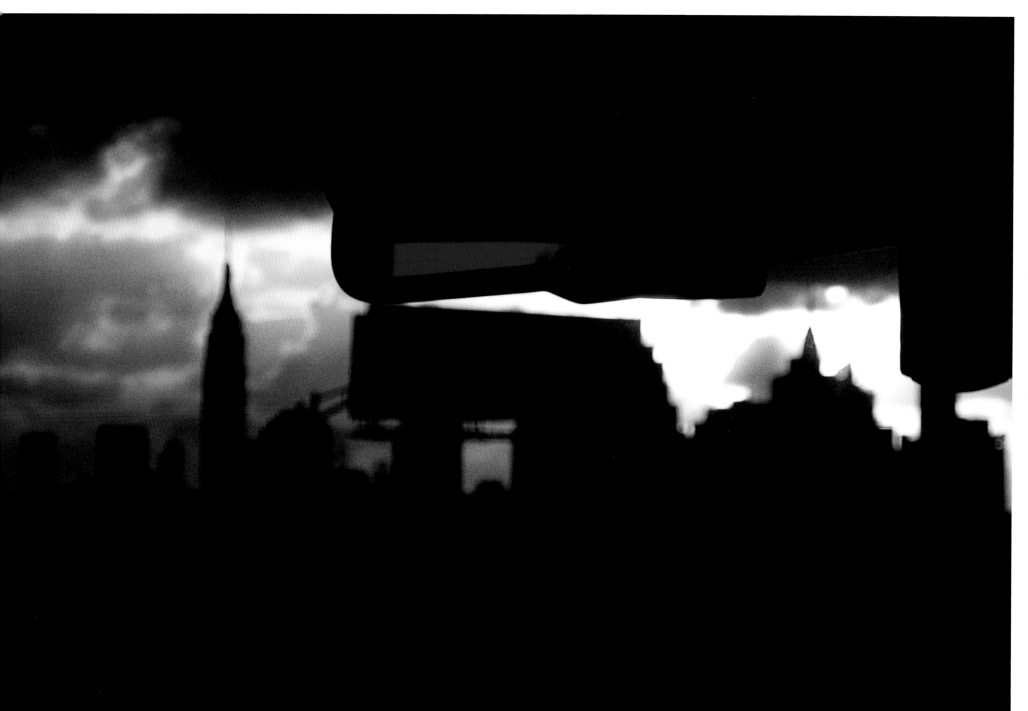

colombia

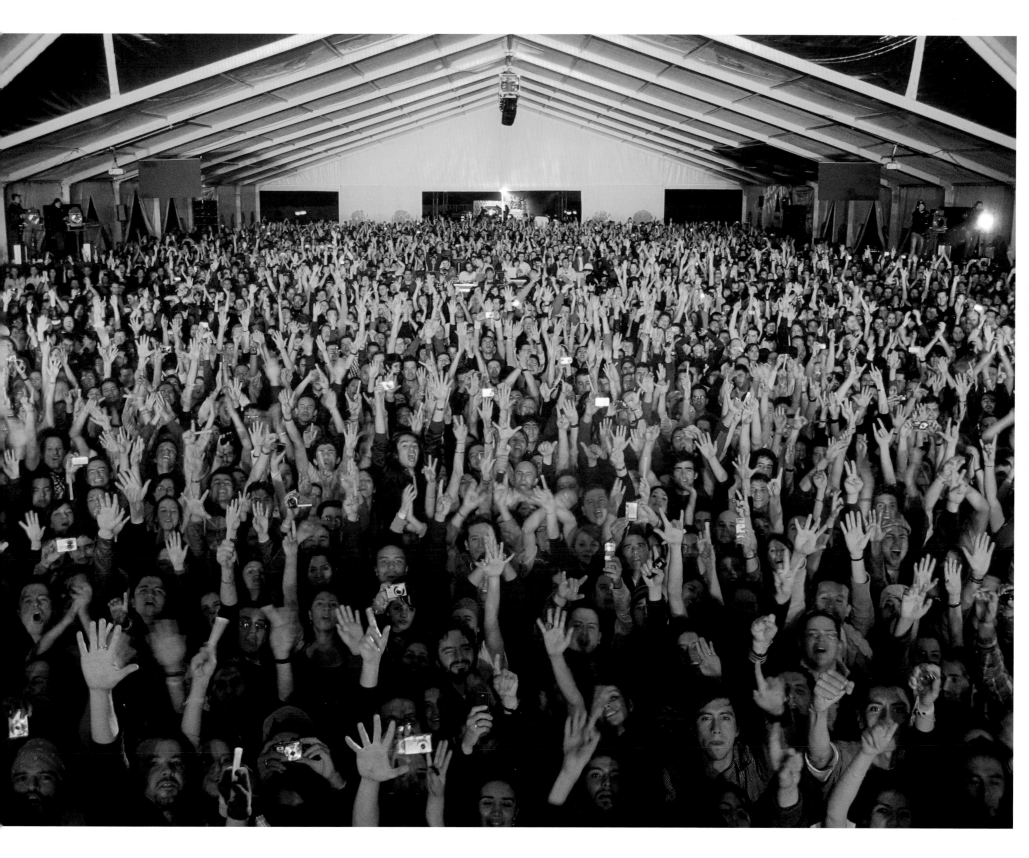

los angeles

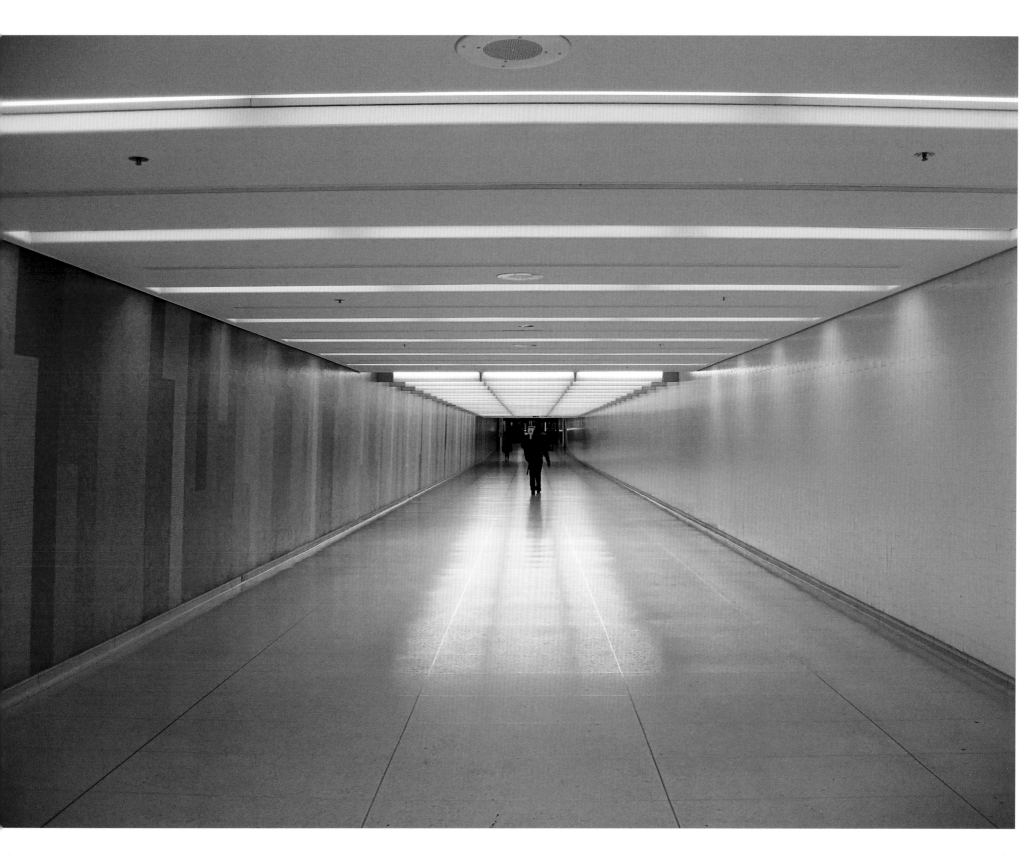

brasilia

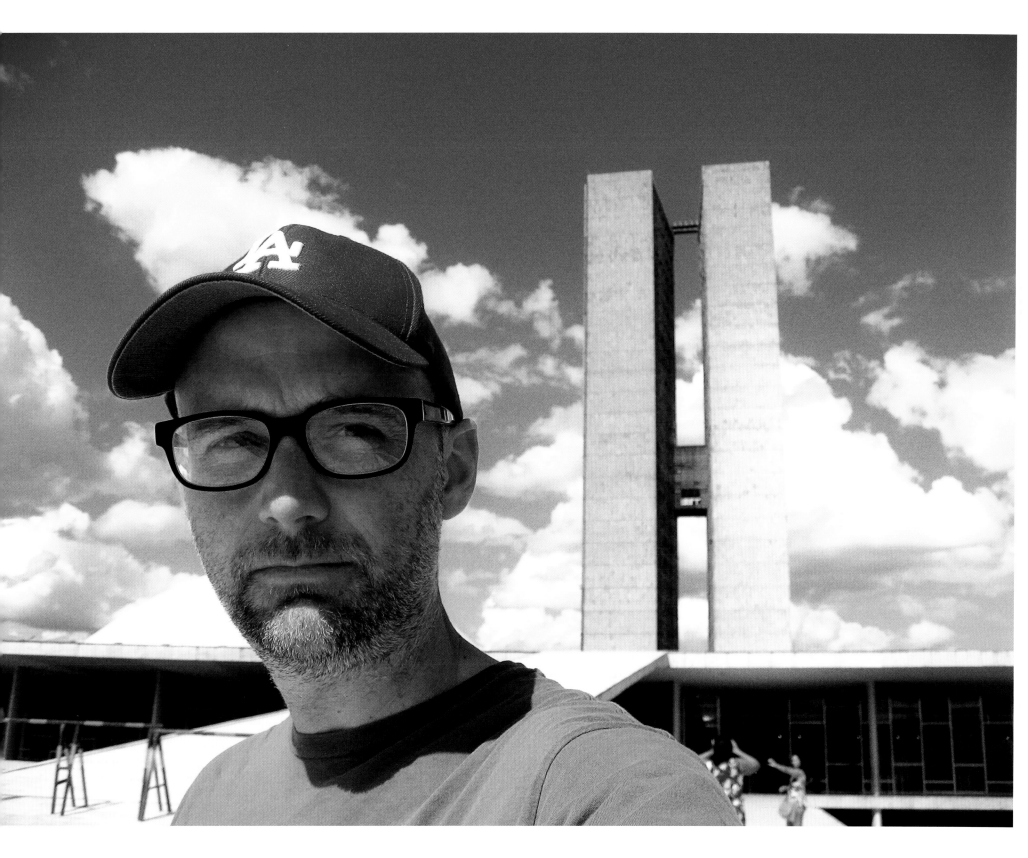

destroyed.

notes

nyc
waiting in a parking lot at jfk airport. i love the sense of isolation and grandeur here. and i might be the only person in the world who loves empty parking lots.

paris
maybe there's something wrong with me in that i'd rather take pictures of flourescent light fixtures than people.

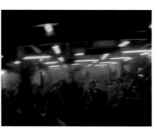

manchester
4 a.m at sankey's. on days off i sometimes dj rather than sit in a hotel room watching 'arrested development' dvd's. this was a long, long, night/day.

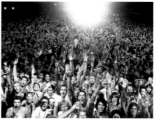

perth
this was a few days after new years eve, but it felt as if new years eve had lasted for weeks.

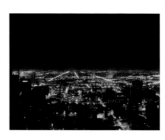

chicago
as i suffer from insomnia i tend to see a lot of cities late at night when everyone's asleep but the lights are still on. i love the way cities are empty and brightly lit at 3 a.m.

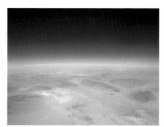

desert, california
one of my favorite things about touring is looking out of an airplane window and realizing that we're somehow flying over a different planet.

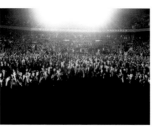

brussels
the amazing thing about crowds is that they're comprised of myriad people but yet they manage to look cohesive.

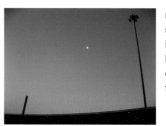

newark
some of my favorite pictures involve 3 or 4 simple elements, like this one. even one other element would've cluttered up this picture.

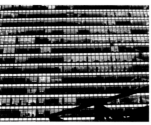

berlin
there's something really comforting to me about office buildings at 4 a.m when the lights have been left on for the cleaning crew.

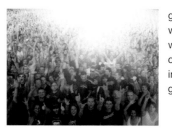

geneva
what i like about this is the way that the crowd is its own context. there's nothing in the image apart from crowd and god-light.

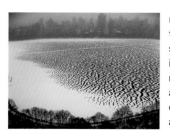

nyc
this is the reservoir at 90th street during a snow storm. i really like cities when there's no trace of the people who actually live there. the snow on the ice looks like whorls on a fingerprint.

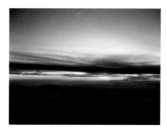

sumatra
maybe this is too decorative, i dont know. to me it looks as if our plane suddenly skipped back in time a few million years.

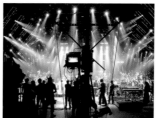

paris
you know, if someone is going to build an insane space ship indoors, well, someone else should take a picture of it. or so i believe.

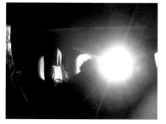

london
another day off, so i agree to do another dj date. to me this feels as if it was taken underwater in a marine zoo.

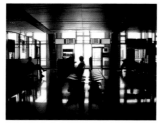

lausanne
a sea of people. i particularly like how the form of the crowd reflects the topography.

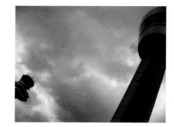

koln
some of the utilitarian brutalist structures at airports are so simple and beautiful. i really like concrete. maybe it's time for the brutalists to have a renaissance.

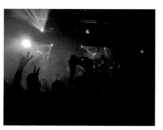

italy
flying somewhere within italy, and this very, very old woman was falling asleep in the sun while reading her book. it's like the sun is looking in on her.

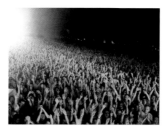

vienna
on one hand i find quasi-empty regional airports to be discon-certing. but i also find them to be strangely calm and beautiful. it's like everything has just ended and will stay this way forever.

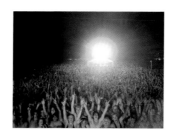

brisbane
i really like the simplicity of this picture. just me, a light, and 50,000 people.

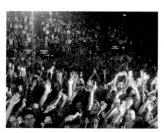

buenos aires
part of my family is argentinian, so playing in b.a. is always significant. i like the different planes of audience here, how there's vertical and horizontal audience at the same time.

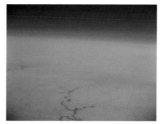

minnesota
again, i love the pictures that feel as if we've left the planet and are in a different part of the universe. it's possible that for a split second we were flying over one of the methane covered moons of jupiter.

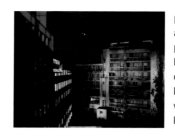

paris
again, i really appreciate the photo opportunities created by buildings illuminated by/for the cleaning staff at 4 a.m. i also love the way old concrete looks when illuminated by fluorescent lights.

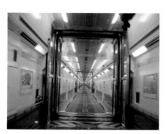

english channel
i still don't know why it's called the english channel, you'd think the french would object...this is in the commercial vehicle part of the tunnel train. to me it feels like the future.

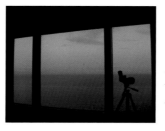

barcelona
another picture with only 3 elements. something about reductionist simplicity is very comforting to me. i also like the idea of telescopes looking at an empty ocean

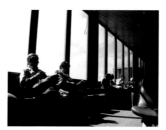

iowa
farmers seem to wait better than the rest of us.

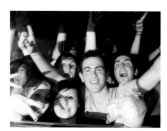

prague
there's something strangely intimate about this picture. the photographers and i are all doing the same thing at the same time. it's like we're on a date together.

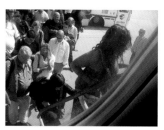

glasgow
as 1/2 of my family is scottish i tend to see the scots as my people…especially at 5 a.m. on a tuesday night.

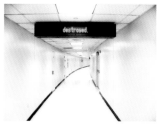

lisbon
the glamor of travel. it's odd that people look so unhappy on holiday.

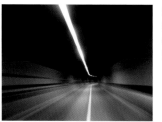

london
actually, maybe it's switzerland. or paris. i don't actually remember. i like tunnels.

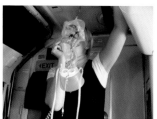

budapest
i love that if you take this out of context it looks like she's kissing a synthetic octopus.

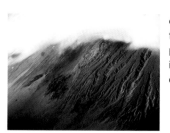

new york
there was this little sign in this weird hallway. it said 'unattended luggage will be destroyed', but one word at a time.

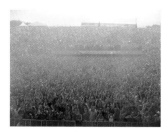

belgium
i rarely play outdoors during the day time. one of the nice things about playing outdoors in the daytime is that the audience is completely visible and illuminated. i was standing in the mouth of a dragon when this was taken.

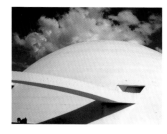

brasilia
the combination of tropical light and oscar niemeyers buildings are almost brutally photogenic.

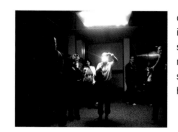

chile
flying over the atacama desert, parts of which haven't seen rain in 400 years. or, possibly, flying over another planet.

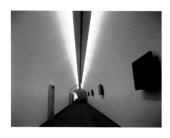

luxembourg
not to sound pretentious, but every architect and contractor is also a sculptor, intentionally or not. this is a hallway and it's a sculpture at the same time. as if dechirico designed an airport hallway.

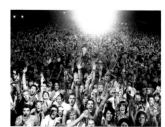

melbourne
new years eve somewhere in a eucalyptus forest a few hours west of melbourne. happy new years, crazy sea of people.

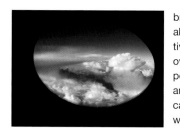

dusseldorf
i really like the limited light sources in this picture. the millisecond of flash and the strange box of light above her head.

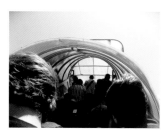

malta
the daily experience of touring. wait. walk. stand. wait. sit. walk. look at back of heads. sit.

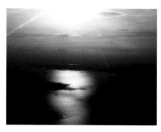

long island sound
the world is pretty simple when seen from an airplane flying from canada to new york.

brazil
although it's simple and decorative, i really like the way the oval window frames this idyllic, perfect cloud scene. it still amazes me that we humans can take pictures of clouds while actually in the clouds.

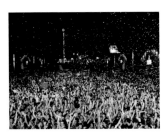

los angeles
there's so much going on in this picture, i wouldn't even know how to begin to describe it. but simply: a lot of humans. a lot of lights. a lot of confetti.

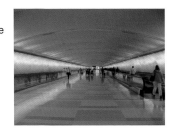

colorado
flying over america in the middle of the winter just feels cold.
i imagine being on the ground and feeling as if it would never be warm again, ever.

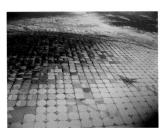

chicago
normally this tunnel is multi-colored. i had to stand and stand and stand and wait for quite a while until it was all one color. in this case: green.

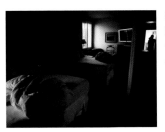

hotel room
i live in hotel rooms. they are functional. they are also almost always strange and depressing.

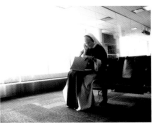

toronto
i believe she is the nun of the future.

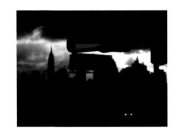

new york
driving home from the airport, stuck in traffic at dusk. and suddenly the storm broke and the sun came through the clouds, making the skyline look ancient and black.

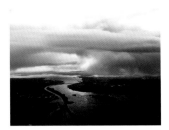

hudson river
i could be pedantic and say that the hudson river is an estuary for the 50 miles or so above nyc. it's also beautiful and wide. i was flying to montreal and a storm had just passed nyc, leaving the sky scrubbed and glowing.

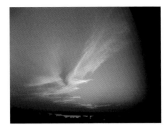

curitiba
i like this picture because the world of humans looks small and dark, and the natural world looks vast and grand and filled with huge birds.

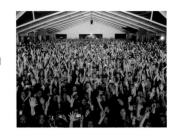

colombia
hands and faces and cameras and a sharp, architectural roof. this was the last night of our tour in 2010.

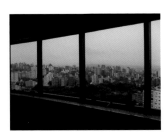

porto allegre
someone thought it was an interesting idea to put blue filters over the windows of this hotel. so this is what it actually looked like to peer through the windows of the hotel. it was like looking out at a land of liquid methane.

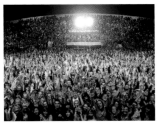

latvia
probably one of my favorite crowd shots. i particularly love the graceful arc of the stadium wall at the very, very back of the picture.

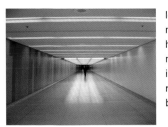

los angeles
maybe it's odd to be a fan of hallways, but this is probably my favorite hallway in the world. i hope they never change or renovate it, ever. the worlds best hallway.

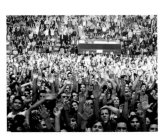

argentina
i love how there's one very human, natural color on the people in the foreground, and one very unhuman, un-natural color on the people in the background.

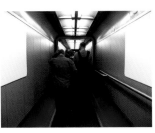

berlin
air travel.

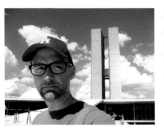

brasilia
someone said, "why are there no pictures of you in your book?" so, now there's a picture of me in the book.

Moby
Destroyed

Graphic Design:
Chris Ritchie

Retouching:
Eric White

Prepress:
Gianni Grandi

Translations:
Teresa Albanese, Isabelle Mansuy, Roberto Masi, Alex Weste

DAMIANI

Damiani editore
via Zanardi, 376
40131 Bologna
t. +39 051 63 50 805
f. +39 051 63 47 188
info@damianieditore.it
www.damianieditore.com

Editorial coordination:
Eleonora Pasqui

Printed in January 2011 by Grafiche Damiani, Bologna, Italy.

ISBN 978-88-6208-155-9

destroyed.